DIGITAL PHOTOGRAPHER'S GUIDE TO
Adobe® Photoshop®
Lightroom™

DIGITAL PHOTOGRAPHER'S GUIDE TO
Adobe® Photoshop®
Lightroom™

JOHN BEARDSWORTH

LARK BOOKS

A Division of Sterling Publishing Co., Inc.
New York

Digital Photographer's Guide to Adobe Photoshop Lightroom

Library of Congress Cataloging-in-Publication Data

Beardsworth, John.
 Digital photographer's guide to Adobe Photoshop lightroom / John David
Beardsworth. -- 1st ed.
 p. cm.
 Includes index.
 ISBN-13: 978-1-60059-111-2 (pb-with flaps : alk. paper)
 ISBN-10: 1-60059-111-6 (pb-with flaps : alk. paper)
 1. Photography--Digital techniques--Computer programs. 2. Adobe Photoshop
lightroom. 3. Data editing. I. Title.
 TR267.5.A355B43 2007
 778.5'2343--dc22
 2007002443

10 9 8 7 6 5 4 3 2 1
First Edition

Published by Lark Books, A Division of
Sterling Publishing Co., Inc.
387 Park Avenue South, New York, N.Y. 10016

© The Ilex Press Limited 2007

This book was conceived, designed, and produced by: ILEX, Cambridge, England

Distributed in Canada by Sterling Publishing,
c/o Canadian Manda Group, 165 Dufferin Street
Toronto, Ontario, Canada M6K 3H6

If you have questions or comments about this book, please contact:
Lark Books
67 Broadway
Asheville, NC 28801
(828) 253-0467

Printed in China

ISBN 13: 978-1-60059-111-2
ISBN 10: 1-60059-111-6

For more information on
Digital Photographer's Guide to Adobe Photoshop Lightroom, see:
www.web-linked.com/lighus

For information about custom editions, special sales, premium and corporate
purchases, please contact Sterling Special Sales Department at 800-805-5489
or specialsales@sterlingpub.com.

Contents

Introduction

Can you honestly say the prospect of evaluating and processing hundreds of digital images has never taken the shine off an exciting day's photography? That's the challenge for Adobe Lightroom, and for this book.

This book is not a feature list–Adobe will produce one of those. Neither is it a beginner's guide for rote learning the various keystrokes and mouse clicks that you'll find for yourself just by using the program–in Lightroom's development, "discoverability" has been a watchword.

This is a much more task-focused book. It doesn't assume you are a busy professional, though you may be, but does assume you are a thoughtful photographer who doesn't really need too much low-level guidance and who doesn't want to take the slow road of learning by experience the best way to work with Lightroom. Far better to have good practice pointed out and to gain the insights that equip you to be productive straight away. It's the best way to keep your head well above the flood of digital images that's constantly coming your way.

In keeping with the product's name, you can turn Lightroom's interface brightness down and then off using the L button, just as you'd turn the lights down to look at a lightbox.

Why Lightroom?

Lightroom was developed as a response to the way digital photography has recently shifted gear. Lightroom doesn't replace Photoshop, or suddenly reveal that Photoshop had always been for graphic designers, not photographers—that was marketing spin. But the program caters for a different style of photography, one whose rhythm is less like working on a single picture in your darkroom and more like getting the pro lab to do a clip test before it processes the dozen rolls you've placed on the counter. Lightroom recognizes that the digital darkroom is giving way to the digital lab.

Digital imaging is well into its second decade, but over the past few years digital capture has become the norm.

Digital SLRs mean professionals and enthusiasts are now often shooting hundreds of pictures a day, which can make the digital darkroom an increasingly stressful place.

Images in the convenient JPEG format aren't always ready to print straight from the camera, let alone fit to send to clients. In any case, many photographers prefer to shoot in raw format and fine-tune white balance, white and black points, and adjust overall contrast later in Photoshop or with raw converters like Capture One or Nikon Capture. To ease this logjam, folder browsers like Adobe Bridge and Photo Mechanic can help you shortlist the best images, letting users tile pictures on screen and zoom in to compare critical sharpness and detail at pixel level.

Yet processing only a shoot's best few pictures wasn't always an option—think of contact sheets and proofs, alternative crops and sizes, web galleries and slideshows. Hundreds of shots a day meant automation was the only practical solution. Actions and scripts made Photoshop open a single picture at a time and perform a variety of editing steps before outputting the finished print and repeating the process on the next shot. Photoshop, raw converters, folder browsers, cataloging programs, and specialized utilities all offered their own take on batch processing.

For some photographers, processing the day's pictures was only the start of the problem, as they also needed database programs like iView and Adobe Elements Organizer to catalog their archive and locate masterpieces buried deep inside this ever-growing pixel mountain.

Many photographers developed a workflow that seemed efficient enough. But it was often a fragile chain, and one that demanded computer skills, aptitudes, and time that not everyone possessed.

Lightroom's new wave

Adobe Lightroom is new in two important ways. Firstly, it is an image editor that is driven by a database, and so it shares with Apple's Mac-only application Aperture the ambition to integrate a large part of the digital photographer's workflow. Secondly, it's also a different type of image editor, sharing certain characteristics with others like Aperture, Lightcrafts Lightzone, and Nikon Capture NX. It's such a new wave that there's no agreed name for it—I'm going for "instruction set image editors" or, better yet, "metadata-driven editors."

Metadata-driven editors are different because they save only the editing instructions or metadata, while traditional bitmap editors save the final output file itself. If that sounds strange, let's say for example you have a raw file you want to print, but with its white balance

warmer, the overall contrast fine-tuned, the picture sharpened, and with a 10-pixel black border.

You've probably opened a raw image in Photoshop, done your work, and then saved it as a TIFF or PSD file in case you're asked for reprints. A metadata-driven editor like Lightroom records your editing steps as you take them, and you can print the image and close the program without ever hitting Save. The next time you want an identical print, Lightroom recalls the editing metadata and repeats those instructions.

One advantage of metadata-driven imaging is the saving in disc space, because the editing metadata is tiny by comparison with the millions of pixels which Photoshop turns from a 15Mb raw file into a 200Mb derivative. That's a big deal now we're dealing with many thousands of pictures.

Saving editing work as metadata also opens up enormous opportunities for automation. It's easier for a program to manage, so Lightroom and Aperture both store it in their databases. Lightzone creates small text "sidecar" files (as can Lightroom), and Nikon Capture NX writes it into the Nikon raw file. Likewise, it's easy to copy editing metadata to other images for more efficient batch processing and alternative versions. And it can be controlled by the same program that manages other "informational" metadata such as captions, keywords, and copyright.

Metadata-driven editors have certain limitations, too. They are designed more for making overall adjustments to many photographs rather than for editing selected areas of an image. Lightroom does have some selective editing features such as red-eye and dust-spot removal tools, while neutral gradient filters and dodging and burning aren't too far over the horizon. In any case, metadata-driven editors are never intended to rival Photoshop's pixel-rendering ability to utterly transform every minute detail of a picture. It's an important distinction.

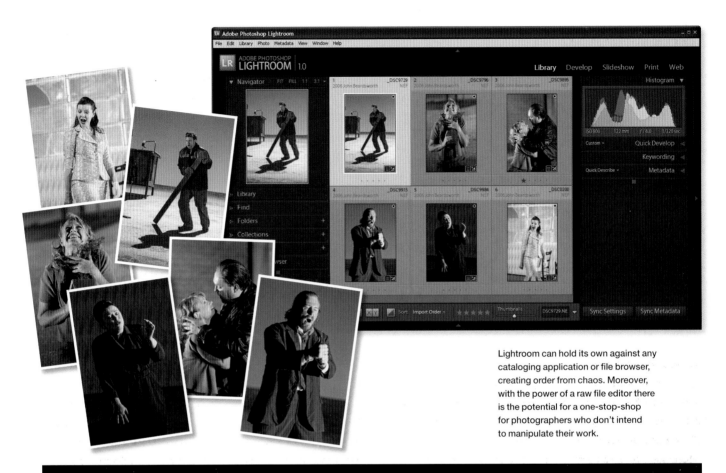

Lightroom can hold its own against any cataloging application or file browser, creating order from chaos. Moreover, with the power of a raw file editor there is the potential for a one-stop-shop for photographers who don't intend to manipulate their work.

Folder browser

A program that directly browses folders and displays image thumbnails and previews, and allows metadata input, as a substitute for the less specialized Windows Explorer or Mac Finder, which must be able to perform a far wider variety of tasks. Examples include Adobe Bridge (that Adobe produce this as well as Lightroom highlights the difference), Photo Mechanic, and BreezeBrowser.

Catalog

A program that records in its database the locations of images and allows metadata input and searches that can span folders, drives, and CDs, DVDs and other offline media. Examples include Adobe Photoshop Elements Organizer, Apple iPhoto, iMatch, iView Media Pro, and Extensis Portfolio.

The five faces of Lightroom

Lightroom works in five main modules, accessed via the toolbar at the top right of the window. This makes getting to grips with the program incredibly easy, and the rigid structure is a refreshing change from the palette madness that bedevils increasingly sophisticated image editors. Each of the modules has its own uses for the panels on the left and right of the screen, while the filmstrip is always accessible from the bottom of the screen.

Library

The Library mode is the heart of Lightroom, where you can view all or select some of your catalog of images, edit their keywords, or hunt for that specific frame.

The panel on the right normally houses the tools for specific tasks, such as the Quick Develop options here in the Library view.

The panel on the left will generally contain content and preset browsers

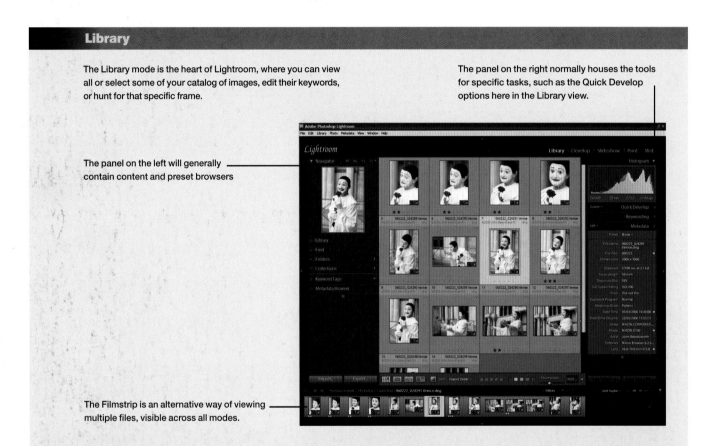

The Filmstrip is an alternative way of viewing multiple files, visible across all modes.

Develop

The develop mode is where you'll make detailed changes to your images. You can crop and rotate, as well as building up a series of time-saving presets. Notice that the right panel, where the tools reside, features a histogram at the top—a sure sign you're now working in something closer to a traditional image editor.

Slideshow

A self-explainatory tool which allows you to create freely distributable PDF slideshows of your work, or simply to see them quickly on screen. Notice the logo at the top left of the page; slides can be personalized with a logo attached to any corner of the display.

Print

Print allows you to print one or more images directly to your printer, as well as adding copyright information, and, just as with the Slideshow, your own choice of logo. This is a great tool for high-speed, high-quality contact sheets, putting Photoshop's equivalent tool to shame.

Web

The Web tool will quickly produce a professional-looking and easy-to-use website for you to upload and share your work, or even upload it to the FTP site of your choice.

Library > From import to evaluation

Imagine returning to your desk with hundreds of shots. No, let's not be too easy on ourselves, we'll say a few thousand. How do you edit and process them all, get some contact sheets out, and select the best to work on later (all in the expectation, of course, that one day you really will find the time to fine-tune them)? You wouldn't want to skimp on keywording and captioning either, because you never know what sort of stock inquiries you'll get. Oh, and I almost forgot, you want everything copied to your backup drive too.

How do you do it? Simple. Import your photographs into Lightroom's Library, ticking the backup option, automatically adding your copyright and contact details from a Metadata Preset—a few shoot-wide keywords, too— and applying your Develop Preset that tweaks the colors and contrast in just the way you like. Add a few more keywords and captions in Library, zoom right in and compare shots side-by-side, discarding a few gigabytes as you go (it'll save you buying a new hard drive this quarter).

Library's Quick Develop tools also let you add that two-thirds of a stop that reveals what's in that sequence of deliberately underexposed shots—and pick out the winners. Of course, you're far too experienced a photographer to leave your camera's white balance set up for tungsten light, aren't you? And surely not all day? Library's Quick Develop fixes those few hundred shots in a few seconds—just in case.

So Library is where you manage your pictures and make enough processing adjustments to identify the rejects and select the winners, those you'll later fine-tune in Develop. Meanwhile, Library catalogs your work in its database and builds a cache of previews that speeds up the rate at which your pictures subsequently appear on screen. But that's happening behind the scenes—you have better things to think about. For now, the pictures are edited, ready for Print to make contact sheets or for Web to put online, and already backed up.

The "Lightroom Library" isn't the Library that you see in Lightroom. It is an area on your computer or network that you can allocate to Lightroom for it to manage files and control subfolders. It can be simply a single folder, or you might devote one or more entire drives to it if you want this "Managed Space" to be Lightroom's main picture storage area.

Importing

Everything starts happening the moment you select *File* > *Import* or when you drag pictures from Finder/ Explorer and drop them into the Lightroom Library. Lightroom's Import Photos dialog presents you with a set of decisions to make, and the following pages aim to equip you with a more detailed understanding of how to make the right choices.

The Import Photos dialog presets two groups of choices. The first set relates to file handling and management—cataloging your files where they are, or where they should be stored, how to name them, and whether to copy them to a backup location. Second is a group of choices relating to metadata—information about the pictures you want to import. This metadata includes "traditional" information like descriptions, copyright, and contact details, but it also includes special processing metadata—instructions on how to process the new pictures arriving in the Library. Both the traditional and processing data are applied through templates or presets (the terms are interchangeable) and can give you really significant productivity benefits once you're up and running. So while the choices under Information to Apply are optional, it makes great sense to quickly get into the habit of applying Metadata and Develop Presets as part of the import process.

2 Alternatively, Lightroom supports drag and drop from other programs or from Windows Explorer or Mac Finder. Make sure Lightroom is in the Library module and position the Explorer/Finder window next to Lightroom. Then navigate to the folder containing the pictures, drag them from Explorer/Finder, and drop them into Lightroom.

1 The most obvious way to get files into the Lightroom Library is to select *File* > *Import* and point to the files or folders that you want to import.

3 If you have used Adobe Elements Organizer to manage your pictures, another choice is *File* > *Import from Elements*.

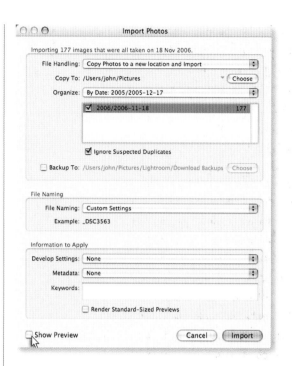

4 If your pictures are still on your digital camera or memory card, open Lightroom and connect the camera or card reader to the computer by USB or Firewire cable. Lightroom should recognize the camera or reader and display the Import Photos dialog box.

Import

Choose a source to import photos from

USB CompactFlash

Choose Files...

Cancel

5 If you select *File > Import Photos* when a card or camera is attached to the computer, Lightroom asks you if you want to import from it, or from the folder system.

6 In each case, Lightroom will display the Import Photos dialog box. If it doesn't show a preview of the images it is going to import, tick the Preview check box.

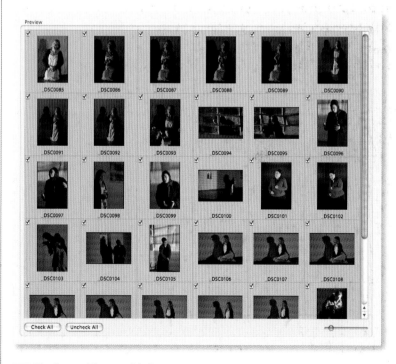

7 The Import Photos grid allows you to scroll through all the pictures that Lightroom is going to import. Each item has a checkbox, and removing the tick will stop Lightroom importing an item. Generally it's better to import the files, examine them properly in Lightroom, and then delete them—otherwise they will remain to clutter up your system.

Import options

To work with pictures in Lightroom, you must import them into its Library. It's much faster to search through a database and display cached images than it is to trawl through folders searching for files and extract and display their embedded thumbnails and previews. This import process doesn't read all the data from your files, or absorb them into its database, but it is a cataloging and cache-building process in which Lightroom records the files' locations, metadata, and other characteristics, and builds

thumbnails and previews. Lightroom then works as a centralized inventory system using captions, keywords, ratings, and other metadata to retrieve your images regardless of where they are physically located.

The first line in Lightroom's Import Photos dialog is File Handling, and the drop-down menu gives you between two and four choices, depending on whether you are importing pictures from a folder location or from another source.

	Folder on hard drive	CD/DVD	Camera or card reader
Import Photos at their Current Location	Y	Y	
Copy Photos to a new location and Import	Y	Y	Y
Move Photos to a new location and Import	Y		
Copy Photos as Digital Negative (DNG) and Import	Y	Y	Y

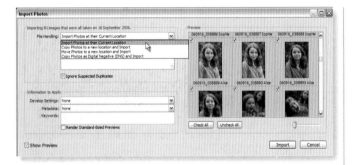

1 Import Photos at their Current Location is most useful when you are importing your existing archive of images into Lightroom and you are happy with their folder location. Files will be left where they are, won't be renamed, and Lightroom will register them by reference to their existing locations.

Since Lightroom assumes you will not want to catalog pictures directly on memory cards, this option is unavailable when you are importing files directly from a camera or card reader.

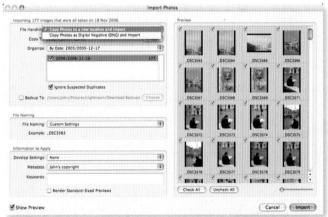

2 Copy Photos to a new location and Import copies your originals to a folder location that you define. Lightroom then uses these copies for all other processing tasks and has no more use for those in the source folder.

This works best if you are bringing new pictures into your Lightroom-controlled system for the first time. For instance, you may have used Explorer/Finder to copy pictures from your camera to a temporary folder on your computer. This feature puts the files where you want them for the long term, lets you rename them, and leaves you to clear out the temporary folder when you are confident that everything has been properly backed up.

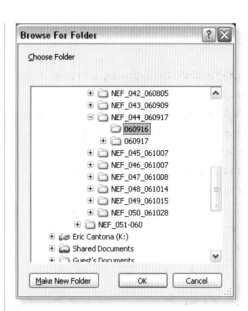

3 Another good application of Copy Photos to a new location and Import is when you have used a portable hard drive to store your pictures while out in the field. Attach the drive to your computer, choose this option, and Lightroom will copy the images over to your computer while also making the thumbnails and previews.

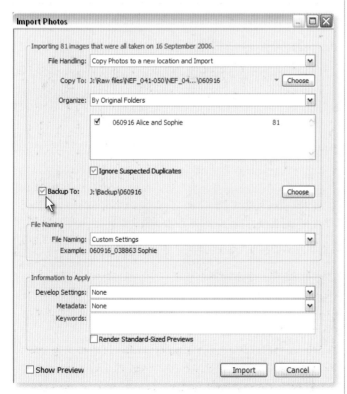

4 If you have chosen Copy Photos to a new location and Import, Lightroom gives you the option to make a backup copy at the same time. This can work both ways. Arguably you can never have too many backups, but at this stage you may only have evaluated the shoot on your camera's LCD screen and not on your computer. So you could also be backing up complete duds, which would still be on your portable hard drive or memory card too.

5 Move Photos to a new location and Import works in a similar way, except that it moves the files instead of copying them. For this reason it's not available when you import images stored on CD or DVD. Here I've chosen the folder where I want the files to go. Notice how the folder name—NEF_044_060917—only refers to the shooting date and makes no attempt to describe its contents.

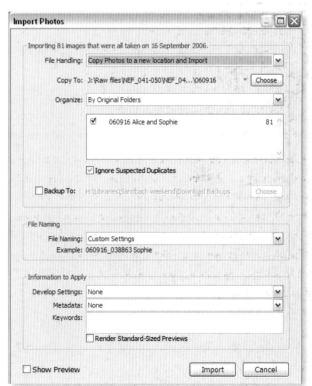

6 Copy Photos as Digital Negative (DNG) and Import makes DNG copies of your files. Lightroom registers those files, not the originals, and uses the DNG files for all later processing. We'll look more at DNG in the next pages.

Renaming

If Lightroom becomes the only program you ever use to manage and process your work, you could then track down pictures through its shoots, collections, keywords and other metadata, and you might see no more need for file renaming. In reality you always have to plan for the eventual day when you do change digital asset management software, and in any case we all want to see images in other programs, as well as in Finder or Explorer. We'll never get away from the need to rename files.

Lightroom lets you rename pictures during the import process, at any time after they are in the Library,

and again when you export output files. I'd argue that it's equally good to rename the originals upon import, or immediately after you have reviewed the shoot and discarded any duds. The timing is less important than following a good file naming scheme:

- Be consistent and logical
- Keep names reasonably short
- Use names that sort well in Finder/Explorer and other programs
- No two files should ever have the same name

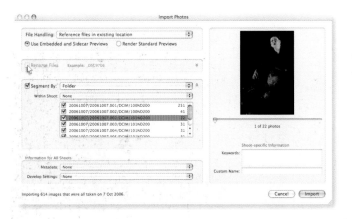

1 When you import images into Lightroom (see page 14), the Import Photos dialog has a section for renaming. This can be quick, though it might also make it harder to reconcile the import to the flash cards if anything should go wrong.

2 As a general principle, once a folder of photographs has been imported into Lightroom, it's best to avoid renaming the files outside Lightroom. This is because Lightroom may lose track of the files if they have been renamed or moved with Finder/ Explorer or another program. This is less of a problem if you are using a Mac since the OS X operating system allows Lightroom to automatically locate any files that have been renamed in the Finder (so long as they are still on an accessible drive). In Windows XP, however, the little question mark indicates that Lightroom can no longer find my originals.

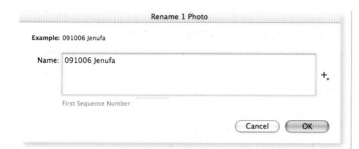

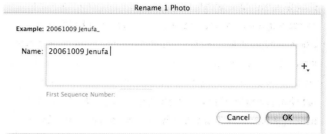

3 To rename individual files, select them in the Library thumbnails view and press F2. Then you can key in the new filename.

4 If your file names include dates, use a scheme that places the year first, then the month, and then the day, and include leading zeroes. This prevents confusion—so here it's clear the shoot was on October 9th—and makes it easy to sort a collection of pictures in date order.

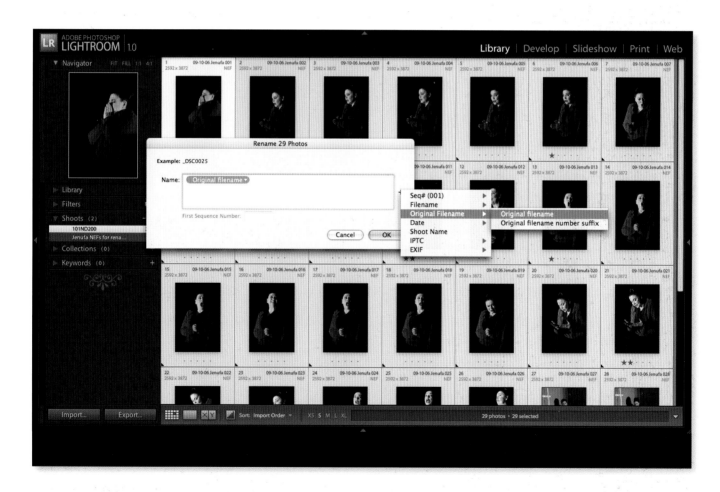

5 When mistakes happen, and filenames contain a misspelling or other error, select the images in Lightroom's Library, press F2, and choose Original Filename from the menu at the right of the Rename Photos dialog box. This restores the files to their names at the point when the pictures were imported into Lightroom.

Good renaming practice

One of the most effective–and common–file naming schemes is to use the shooting date and a sequential number, so images might be named "20061017-1234.cr2" "20061017-1235.cr2" and so on. Apart from meeting the key criterion that no two originals should have the same name, it's easy to sort these images in shooting order in Finder/Explorer or any other program. The scheme is also flexible enough for most multi-camera situations.

Purists argue that you need not include anything at all after the unique Date + Sequence Number combination, since you can include any description in the metadata. But a little description helps you scan the filenames in Finder/Explorer or in other programs that can't read the metadata, so I consider it best to include a word or two that applies to the whole shoot. Here I simply added the opera name–renaming down to performer level would have served no purpose.

Another key point is that it is generally best to put any description after the unique Date + Sequence Number part of the filename. This keeps it easy to sort the pictures in the order in which they were shot. However, you might sometimes want to place the photographer's name first if you are sending files to a client, or if you anticipate sorting the images in that order outside Lightroom. In short, there's no cast-iron rule, but following the rule above will prove very useful.

2 To make sure the pictures are renamed in strict shooting order, Library's thumbnails should be sorted in capture sequence.

1 The best times to rename pictures are either when they are first imported or when you have made an initial review and deleted substandard images. In the latter case, this renaming scheme means your client will never notice any gaps in the file numbering sequence.

3 Select the images you want to rename and choose *Library > Rename Photos* (F2). Leave Original Filename selected and highlighted.

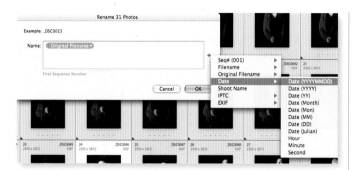

4 From the menu at the right of the dialog box, choose Date and then YYYYMMDD. Original Filename will now be replaced with Lightroom's code Date (YYYYMMDD).

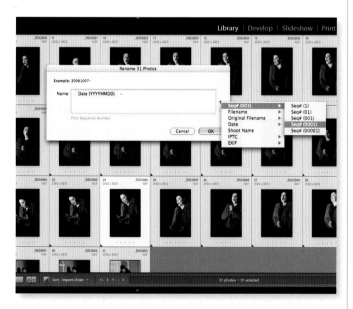



5 Add a dash to separate the date from the sequential number. This helps scan a list of files, and it's useful for searching—if I remember an image has "1215" in its name, I can search for files with "-1215." Leaving out the dash would mean I could only search for "1215" which would also return images shot on December 15th.

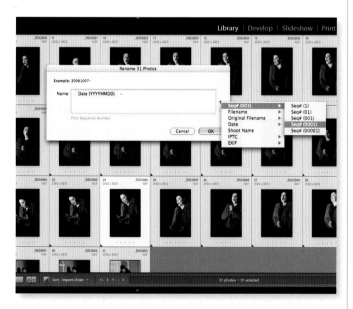

6 Now select the sequence number from the menu at the right of the dialog box.

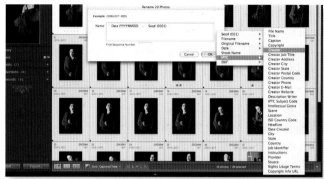

7 You may want the filename to include the photographer's name, particularly if you were working with a colleague. If you already added the creator details to the images, for instance when you imported the images and applied a metadata preset, then pick the name from the Rename Photos dialog menu.

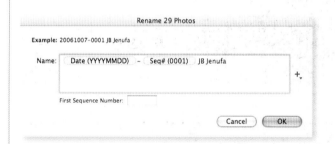

8 My name uses too many characters and I was working alone, so I simply typed in my initials and the name of the opera.

The finished renaming job. Notice that my initials and description are at the end of the filename, making it easy to sort by the unique Date + Sequence Number combination when I'm not in Lightroom.

Copy Photos as Digital Negative

We have seen that Lightroom's Import Photos dialog has an option "Copy Photos as Digital Negatives (DNG)," and it's worth thinking about what that means before deciding to choose or reject that option.

If you are not familiar with the term, DNG is an Adobe-sponsored format for photograph files that places the raw image data in a publicly documented format.

The resulting DNG file contains the raw image data, embedded previews and thumbnails in JPEG format, and carries metadata in an open XMP (Extensible Metadata Platform) format. Opinions vary widely on whether to use DNG, so let's look at the implications of choosing that option in Import Photos.

Tip >

You can convert images to DNG format upon import, export, or in the Library.

Advantages of converting to DNG

1 DNG is a lossless file format, so Lightroom wraps the image's proprietary format raw data and any metadata in a publicly documented format. The raw data is not demosaiced, so the DNG is still effectively just another sort of raw file.

2 Unlike a raw file, though, DNG is publicly documented, increasing the chances that the file will still be readable in 10, 20, or 100 years. While there's an archival case for DNG, it's more likely that photographers will find a wider choice of programs that can read DNG than, say, the raw files from a camera whose manufacturer has pulled out of the photography business in the last few years.

3 The DNG format allows copyright information, captions, keywords and other metadata to be written directly into a file, and its open specification means software developers can give us tools to do so safely. With raw files, developers have to guess, or write metadata into XMP "sidecar" files that clutter up your folder system.

4 The DNG contains a large preview which shows the current appearance of the image. If you got the white balance wrong in camera, or got the horizon off beam, the DNG will show the corrected image. Other imaging programs can read this corrected image quickly, so it's as if the DNG file is making available a finished rendition.

5 The DNG file is often significantly smaller than the raw file. On its own, this is not a reason for switching to DNG, more a happy by-product of the relative efficiency of Adobe's compression routines compared to those used by some camera manufacturers.

Disadvantages of converting to DNG

1 Not all raw converters will read DNG, so your choice of rendering tools is limited. So if you often process images through other tools, switching to DNG might limit your options or force you to keep your raw files as well.

2 It takes time converting raw files to DNGs. For studio or high-volume work, when you want to see the results almost immediately, there may not be time to convert pictures to DNG upon import.

3 If you do convert to DNG, what do you do with the raw files? Some DNG enthusiasts, professionals included, discard them entirely since they see no farther need for them. Others don't, partly out of caution. I'm in the latter camp, but I rarely look at my Nikon raw files again after making my DNGs.

4 DNG is still a relatively recent initiative, so one must always wait and see what develops. Using DNG is not a matter of being professional or amateur—I've met both types of photographer who embrace or reject the idea. For me, the key was that I liked having a corrected preview and writing metadata directly into the DNG "originals"—and having that information cascade into any derivatives made from them. So once I've copied the images as DNGs, I archive the raw files themselves—just in case. It's a very personal decision.

Tip >

Even if you do convert to DNGs, you can still keep your raw files.

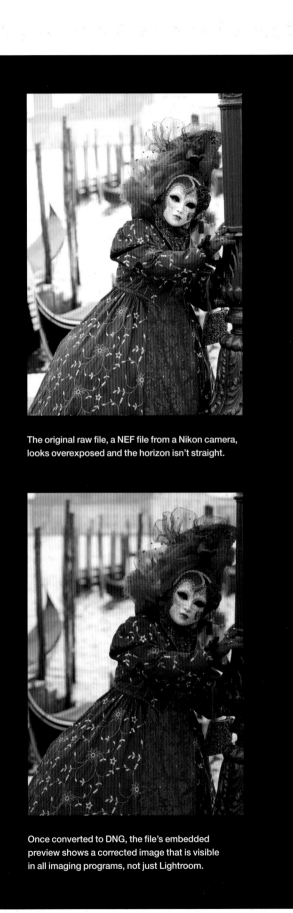

The original raw file, a NEF file from a Nikon camera, looks overexposed and the horizon isn't straight.

Once converted to DNG, the file's embedded preview shows a corrected image that is visible in all imaging programs, not just Lightroom.

Automated importing and tethered shooting

Digital capture utterly changed the way some studios work, allowing commerical fashion and product photographers to connect their cameras and computers and see their pictures on screen moments later. No more need to switch to the Polaroid back, review the results, and then try to repeat the shot with film. Tethered shooting means every shot counts and test shots don't eat into the budget or test the patience of models or any clients who may attend the shoot.

Lightroom doesn't control the camera, so for now you still need the manufacturer's camera-control software.

Once Lightroom is set up to watch the folder where new pictures arrive on the computer, it then automates the import process and can apply both Library and Develop presets to new shots.

So, for instance, you may wish to underexpose a series of pictures to retain the highlight detail. It's not difficult to set Lightroom up to automatically rename the pictures, back them up to another drive, add your copyright and shoot details, and then apply a Develop preset that lifts the midtones and the shadows.

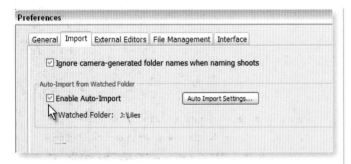

1 The key settings for tethered shooting are in Preferences (*Edit > Preferences* on the PC or *Lightroom > Preferences* on the Mac). Go to the Import tab and tick the Enable Auto-Import check box.

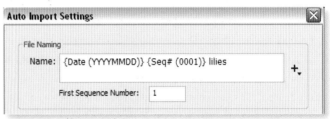

3 Click Auto Import Settings. Here you can save yourself time by making Lightroom rename new pictures as it imports them. In step 2 you can see that my camera's control software was creating files named "Img0001" etc, but here Lightroom will change the filenames so they follow my preferred Date + Sequential Number + Quick Description convention.

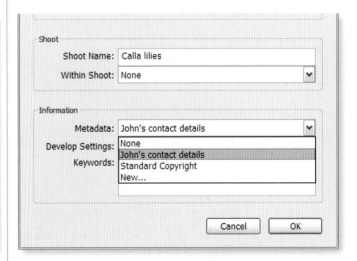

2 Now Lightroom is watching your file system for new pictures, double-check the Watched Folder setting below Enable Auto-Import. It needs to point to the folder in which your camera-control software is saving new pictures—here Nikon Capture Control Pro is set to save new shots to J:/Lilies. If these folders don't match, adjust your camera-control software or click the Choose button to the right of Lightroom's Watched Folder setting.

4 Next, enter a shoot name—Lightroom will save your files into a similarly named folder—and choose your copyright metadata template from the Metadata drop-down box. It's worth emphasizing here that if you haven't already set up such a copyright preset, you're making work for yourself and running the risk of sending out pictures without your contact details. So if you've not done so, backtrack a little and create that copyright template—it'll save time in the long run.

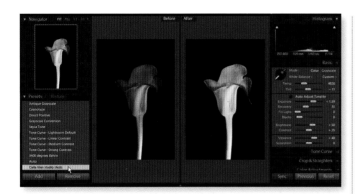

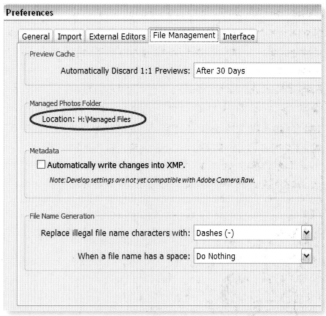

5 Lightroom can also process and adjust shots while it is importing them from a tethered camera, so you immediately see the pictures on screen in their near-finished state. For this to work, you're going to need a Develop Preset, some of which ship with Lightroom. In practical situations you'll often set one up specifically for the shoot, matching its lighting conditions and the subject.

In this case I did some untethered test shots, imported them from the card, and processed them. This included both corrections, such as cooling the white balance, and more interpretative changes like brightening the image with the Exposure slider. The highlights were pulled back with Recovery, the background clipped a touch with the Blacks slider, and I'd gently boosted the colors with Vibrance. Don't worry if this all seems a bit hard to digest—we'll look at these controls in more detail later in the book. The important thing is that I saved these adjustments as a Preset called "Calla lilies studio shots."

7 Before closing the Preferences dialog box, go to the File Management tab and check that the location of Lightroom's Managed Photos area. This is where it will move files as they are imported and processed—here it's a folder on my H: drive where I have plenty of space.

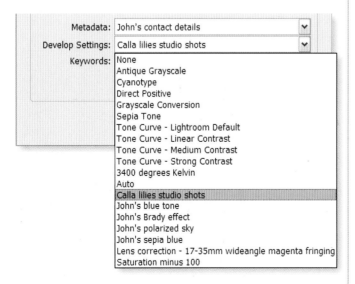

6 Assuming you have a Develop Preset you want to apply, choose it from the Develop Settings drop-down menu, and click OK to close Auto Import Settings. Here all my tethered shots will have the same "Calla lilies studio shots" appearance.

8 In Lightroom's Library, set the sort order so that pictures will be shown in descending order of their capture time. This means that the newest pictures will appear at the top of the screen and you won't have to keep scrolling down to review the latest shots.

Databases and folders

It's now worth backtracking a little and thinking about how many Lightroom databases you need. When Lightroom starts up for the first time, it creates a database file called "Lightroom Database.lrdb"–this is where all the processing information and metadata is stored. Each time you subsequently open the program, it's this same database that is always accessed, and you can continue adding more and more pictures to it. It's designed to manage all your pictures, not just process new ones.

In general, one would work with a single database per computer, managing and processing all your pictures through Lightroom as though they are all in one big bucket. Another way to think of Lightroom is as a centralized inventory system managing a warehouse–you no longer need to look through each pallet or bin location to find the parts. And while your business grows, and you rent the neighboring warehouses too, you still only need one system to keep control of your work.

Even when you have tens of thousands of pictures, with everything in one big pot, you can use the Left Panel (F7) to filter the database down to just the group of pictures you need. At first, if your pictures have no keywords or other descriptive metadata, you may be relying rather too much on the Folders panel. The more metadata you add to your pictures, the easier it becomes to locate them, and it's well worth getting into the habit of saving plenty

of Collections–"virtual sets" that you can use to gather together related pictures from all over your folder system.

While ideally a single database is the way to go, Lightroom does allow for the possibility of working with more than one database, and there are many possible reasons why you might want to do this.

- You may already have a trusted cataloging program to manage your photographs, and be reluctant to move those management tasks to Lightroom, particularly the first version of the program.
- You may feel no need at all for a program to find your pictures–a photographer who only shoots weddings may keep everything in folders with one for each date.
- You want to segregate part of your work–for instance, an important project with a much shorter set of keywords. Personally, I'd opt for keeping it in the big database instead, but that's a matter of personal preference.
- The volume of your work may be very great. Lightroom version 1 uses an SQLite database (in the future it will probably support other, enterprise-scale databases), and can accept many thousands of pictures, but check Adobe's site for the latest recommended limits. One workaround would be to use quarterly databases, or one database per disc drive–split by a physical division rather than something as subjective as how you analyze your subject material.

Tip > Collections

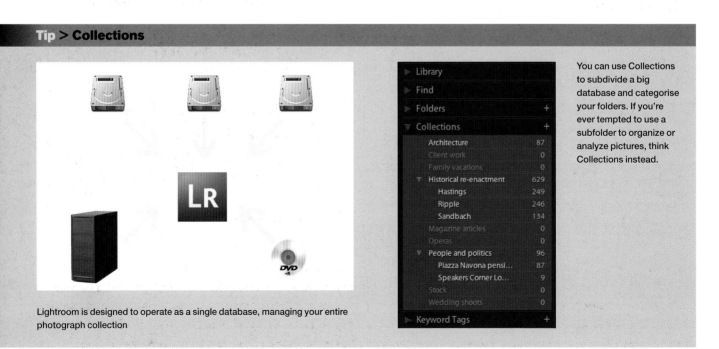

Lightroom is designed to operate as a single database, managing your entire photograph collection

You can use Collections to subdivide a big database and categorise your folders. If you're ever tempted to use a subfolder to organize or analyze pictures, think Collections instead.

And there's one last reason for working with multiple databases—in the early days, it's pretty easy to mess things up, and you may need to start all over again. That's not as facetious as it might sound. A good way to learn Lightroom would be to spend the first two to three weeks trying out as many features as you can, using and abusing every aspect of the system, making plenty of silly mistakes—and some imaginative ones too. While Lightroom won't change your original files, you could use dummy copies. Tell yourself that your first database(s) will be trashed at the end of that period. You'll then be armed with the experience from the dry run and be in a great position to move on at full speed.

On the other hand, don't have too many databases or leave them spread all over your system. Lightroom is designed to manage all your photography and can bring order from the chaos of multiple drives and folders, but it can only search one database at a time. Start fragmenting the database that controls your picture collection, and you lose some of the benefits of the central inventory system.

Create a new database

To create a new database, you must first close Lightroom. Then, as you restart it, press and hold down your keyboard's Alt/Opt key. Be quick—you need to press Alt/Opt within a second or so of clicking Lightroom's icon in the Mac Dock or on the Windows Desktop or Start menu. Then click the Create New Database button.

Switching between databases

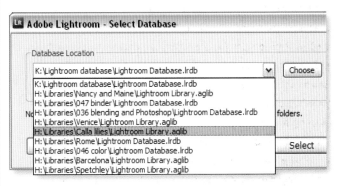

To switch from one database to another, restart Lightroom and press and hold down your keyboard's Alt/Opt key. Then select the file from the Database Location drop-down box.

Lightroom as image processor only

Add initial metadata
Process and print/output
Write to SMP sidecars

Add extra metadata
Find and manage files

An alternative way to work with Lightroom is to use it purely for processing, and rely on your existing cataloging program for management and searches. Evaluate images in Lightroom, add initial metadata and process the pictures you decide to keep.

Reading the metadata in a third-party program

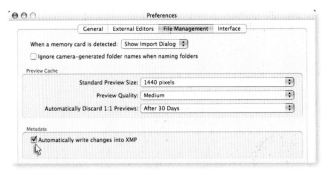

For another program to read metadata added in Lightroom, the pictures should be in DNG, JPEG, TIF, or PSD format—Lightroom can write metadata directly into these formats. Alternatively, particularly for raw files, the other program will need to be able to read XMP sidecar files. Tick the "Automatically write changes into XMP" checkbox.

Folders

When you see your pictures in Lightroom, you are looking at database records and not directly at the files themselves. Lightroom is a cataloging application, not a real-time browser of your folder system. This makes performance much faster with collections of pictures spread over many drives, but at times there are disadvantages to the pure catalog approach. So Lightroom also has the Folders panel.

When files are imported, Lightroom analyzes the folder path and adds items to the Folders panel. The panel is like a folder tree, so you can click an item as though it was an Explorer/Finder subfolder, and you can move files between folders by dragging and dropping, just like in Explorer/Finder. However, it's important to understand that this panel shows where Lightroom thinks the files are. That is not necessarily the same thing as where they are right now–files don't usually move themselves and as likely as not you may have moved them outside Lightroom.

You can move files between folders. This is the same as dragging and dropping them in Explorer/Finder, but better in the sense that Lightroom doesn't lose track of where you moved them to.

As a general rule, once you have cataloged pictures in Lightroom, use Lightroom for all file operations like renaming, moving, and deleting picture files. In my case, this means I never move Nikon raw files in Windows Explorer. On a Mac, the rule is less rigid because the OSX operating system tracks files regardless of their names, so you can use Finder to rename or move files, and Lightroom will still know where they are. Yet there are still times when, for one reason or another, files will not be in the place where Lightroom recorded them, or when you want to change the folder structure.

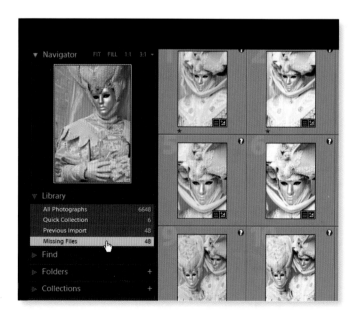

1 Look out for warning signs. If Lightroom can't find files, the Library panel (F7) shows the count of Missing Items. A second indicator is the small black circle and white question mark that appears on the thumbnails.

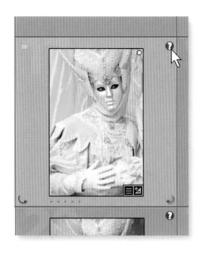

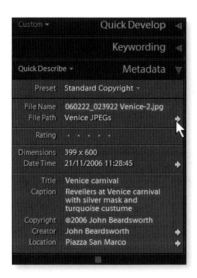

2 You need to help Lightroom out and tell it where the files are. So click the question mark on the thumbnails.

5 As well as the missing file to which you pointed, Lightroom also automatically fixes the locations of other missing files that it finds in that folder.

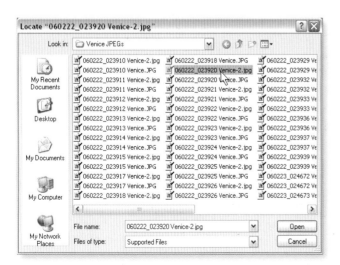

3 Alternatively, click the arrow next to File Path in the Metadata panel (F8).

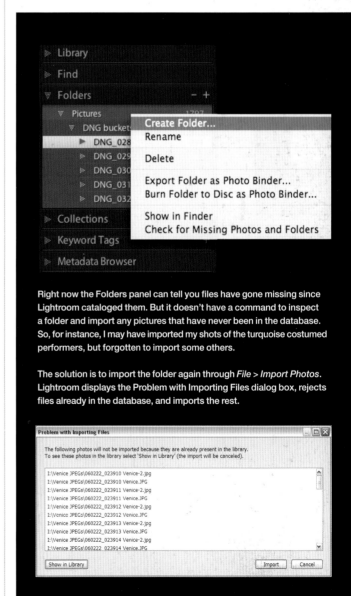

Right now the Folders panel can tell you files have gone missing since Lightroom cataloged them. But it doesn't have a command to inspect a folder and import any pictures that have never been in the database. So, for instance, I may have imported my shots of the turquoise costumed performers, but forgotten to import some others.

The solution is to import the folder again through *File > Import Photos*. Lightroom displays the Problem with Importing Files dialog box, rejects files already in the database, and imports the rest.

4 Point Lightroom to the missing file. Notice the file's name is in the title bar, so make sure you click the same filename in the new location (unless you had renamed the original outside Lightroom).

Stacks

Modern cameras can shoot many frames per second and it's not unusual to have large numbers of almost-identical images of fast-moving action or events. Photographers who are able to shoot at a more leisurely pace may take pairs of images, bracketing them so that they can later blend the over- and underexposed images to increase the dynamic range of the final image. Digital has also increased the popularity of stitching large images, especially panoramas, from a number of shots. There are plenty of other variations on this same theme: shooting multiple frames for what is essentially one final image.

There are times when you want to see each shot in the thumbnail grid, but at other times that can be inconvenient. So, just as you used to gather piles of already-viewed slides on a lightbox, Lightroom lets you "stack" your thumbnails.

2 Select a group of related pictures and choose *Photo > Stacking > Group into Stack*, or use the keyboard shortcut Ctrl/⌘+G.

1 To create a stack manually, go into Library's Grid view (G) and select the best image in the group. Then use Ctrl/⌘ and Shift-click to add the rest of the group. Here I was switching my lens between the curly-haired protester and her less high-spirited colleague, so I Ctrl/⌘-clicked alternate images.

3 When images are stacked, all the thumbnails disappear, except for the shot you first selected, and a small number appears at its top left to indicate the number of frames in the stack. So here, instead of my original 40 thumbnails, I now have just the eight most representative shots.

4 You can combine stacks by selecting each one and pressing Ctrl/⌘+G again, or you can break up a stack by selecting it and using Ctrl/⌘+Shift+G. Alternatively, press S and you can expand a stack into individual frames; a second S stacks them again. Here the four shots of the curly-haired protester are all visible, while the other shots are stacked. Notice too that these shots are numbered 1-4, with 1 being the top of the stack.

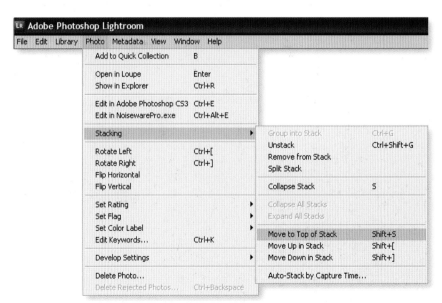

5 Often with stacks, you want to change the image that represents the rest—the item numbered 1. Select the shot you want to promote, and choose *Photo Stacking > Move to Top of Stack*. Alternatively, use the keyboard shortcut Shift+S.

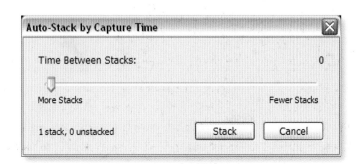

6 When the shoot consists of bursts of images, for instance if you're shooting weddings or events, you can use auto stacking. Lightroom looks at the gaps between frames, so if you shot five frames in two seconds, waited half a minute and then took three more in a second, the two stacks would be divided by at least 20 seconds—so set the slider accordingly.

Copyright and contact details

Adding your copyright and contact information is not as exciting as rushing on to the Develop mode or seeing the first print emerge from the inkjet printer, so it can very easily be overlooked. The risk then is that you might transmit pictures to your clients that don't contain your contact details.

But this information is obviously important and adding it need not be a chore if you let Lightroom do a lot of the work. The key is to create a Metadata preset containing those details, and to apply it every time you import images into Lightroom.

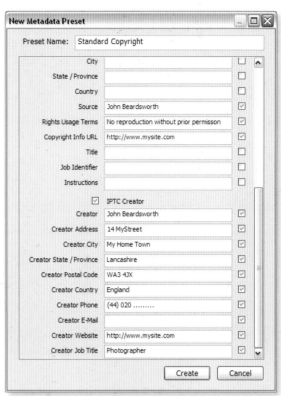

2 Assign a meaningful name and enter the key copyright details. Scroll all the way down and make sure there isn't any irrelevant information which may already have been applied to the image's IPTC data. Click Create when you're done.

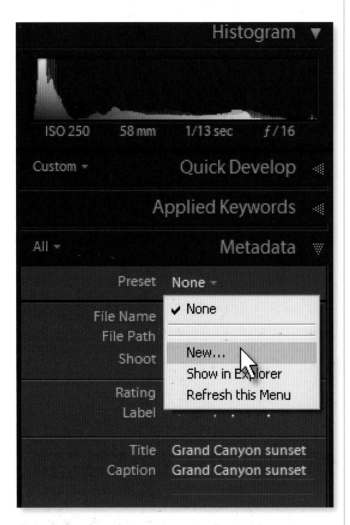

1 Select an image in Library, display the Metadata panel (F8), and choose *New* from its Preset drop-down menu.

3 Next time you import pictures, choose your copyright preset from the Metadata drop-down menu, which you can find at the bottom left of the Import Photos dialog box. From now on, Lightroom will continue to apply it to subsequent imports.

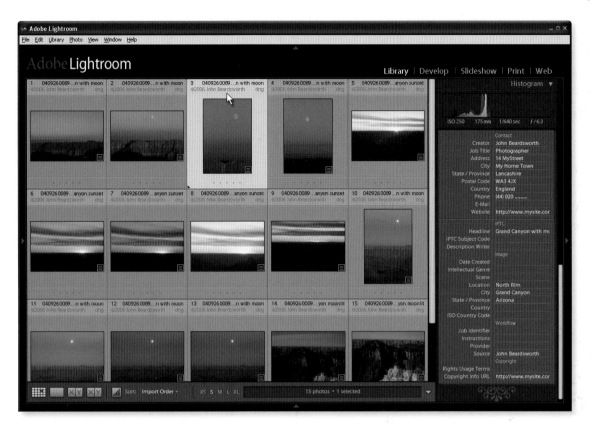

4 Review the results in the Library. Here I pressed the J key until the thumbnails showed my copyright symbol, and you can also see the information in the Right Panel (F8).

5 To apply the preset to pictures you've already imported, select them in the Library, display the Metadata panel (F8), and choose your preset from the Preset drop-down menu.

6 If you need to find the Metadata templates, perhaps to copy them to another computer, in the Metadata panel the Preset drop-down box has a *Show in Explorer/Finder* option.

Keywords

Adding keywords and other metadata takes time. For some photographers this chore brings no obvious future benefit, as once the job is billed they never again need to find the pictures. But there are others who need to add as much relevant metadata as possible so they can meet customer inquiries for stock shots. It's usually an individual trade-off between the value of one's time and the richness of description.

Lightroom caters for these varying needs–you can choose either to enter individual keywords and metadata for each picture, or to update hundreds of images with a single click.

Simple ways to enter keywords

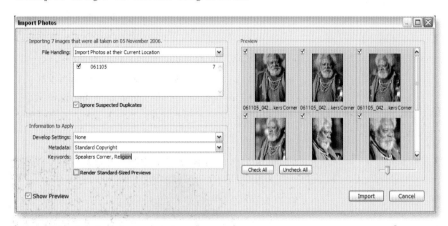

1 When you're importing pictures, it makes sense to enter keywords shared by all the pictures. In Lightroom's Import Photos dialog, type directly into the Keywords box—as you type, Lightroom uses predictive text code to match to existing keywords.

Keywords are words and short phrases that describe a photograph, and can be as specific as "Speakers Corner" (an area of London's Hyde Park) or as abstract as "Religion."

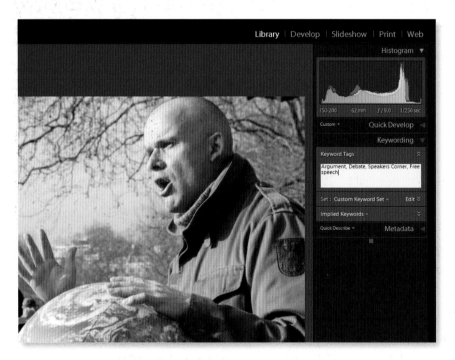

2 In Library, select items in the grid view (G) and enter more specific keywords in the Right Panel (F8). A good rule of thumb is to use all the words you need to describe the picture to someone who cannot see it, so don't be deterred if the keyword list becomes lengthy. But avoid synonyms so loosely related that searches produce a spam-like profusion of irrelevant pictures.

Think about how you or someone else would want to search for an image like this. "Argument, Debate, Speakers Corner, Free speech" sum up what's in this picture, and perhaps "Heckling," "Globe," and "Bald" too.

Better ways to enter keywords

While it may be acceptable typing in the same keywords once or twice, it becomes a little tiresome when you enter the same combination of keywords each time you've photographed the same subject. And that can happen quite frequently. For instance, wildlife photographers might want to include scientific and common names and add the keywords "Haliaeetus leucocephalus, Birds, Eagles, Raptors" every time they add the keyword "Bald Eagle." Other photographers may need multilingual keywords, so pictures from Venice are also keyworded "Venezia, Italia." Under time pressure, spelling mistakes creep in, or you forget some synonyms, and you then waste more time working out why the picture isn't found in a search. One way to ease the strain is to build a keyword hierarchy with synonyms.

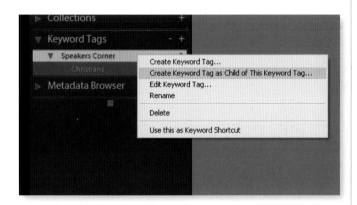

1 First decide on your subject's main keyword, in this case "Speakers Corner," and add it to the Library's Keyword Tags panel (F7) by clicking the + button.

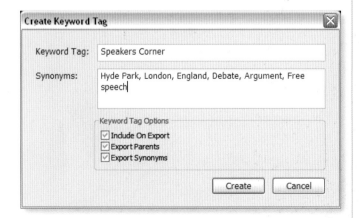

2 Make sure you add related words too. These can be true synonyms or words like "Hyde Park" and "free speech" that are synonymous with your subject. You can always add more later.

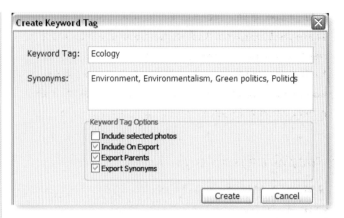

3 Then start adding more detail to your keyword's hierarchy by right-clicking it, selecting Create Keyword Tag as Child of this Keyword Tag, and entering the detail. Here I'm adding "Ecology" with the synonyms "Environment, Environmentalism, Green politics, Politics"

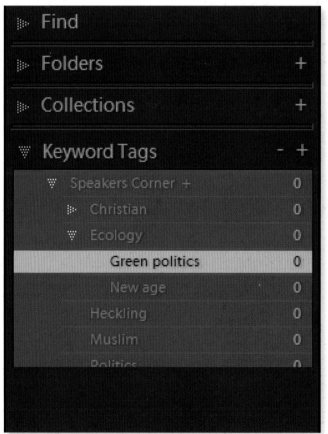

4 Repeat the process and add more levels. Here I've added "Green politics" and "New age" to my structure.

5 You can always right-click a keyword and edit its synonyms.

6 To keep some keywords private, untick Include On Export in the Edit Keyword Tag dialog box. For instance, you may want to mark some images with the keyword "Ugly" but not have the word included in the metadata of images you email to clients.

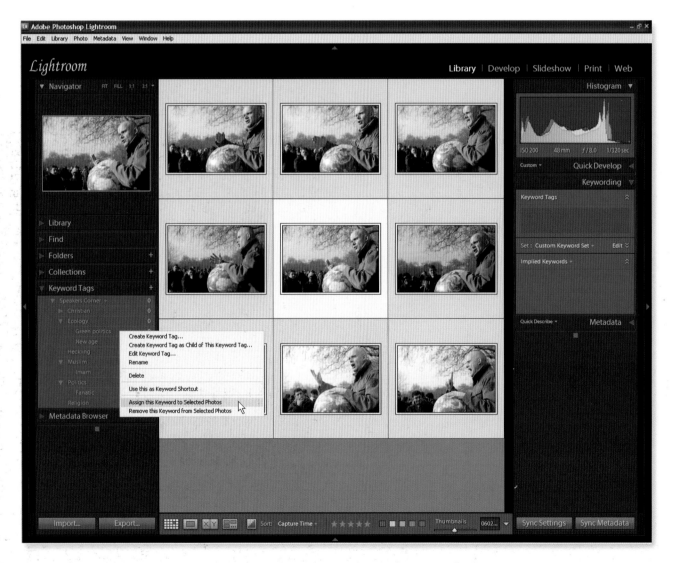

7 To make use of a hierarchy, drag images from Library's grid and drop them on the appropriate keyword. Here I drag my shots of the heckler onto that keyword.

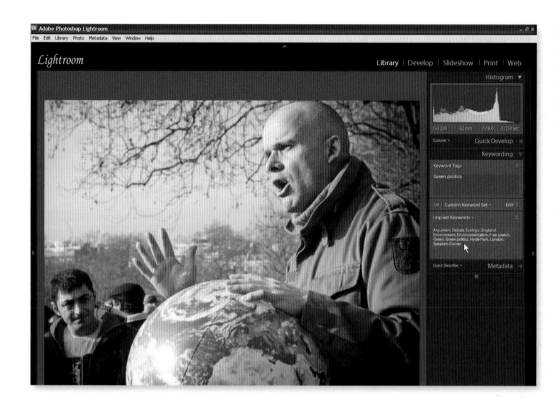

Notice how only the keyword "Heckling" has been applied to this image. Because I had defined "Heckling" as a child of the "Speakers Corner" keyword, Lightroom will add the other implied keywords when I next output the file.

Using external keyword lists

Lightroom allows you to import keywords from text files. This can be useful if you are migrating from another system able to export text files, or if you need to apply keywords from a "controlled vocabulary" supplied by a stock agency.

1 To import keywords, the text file can be a simple list.

2 For hierarchical keywords, Lightroom needs the keywords to be laid out in a particular format using Tabs to identify the levels. The external list may not be in the required format so you will have to edit it with Notepad or TextEdit. If you've done data migration exercises before, you may find Excel helps you manipulate long lists.

As a first step in any data migration, I like to look at what my target program will export. Most of the time, its export format will be the same as the format of files it can import. So construct a keyword hierarchy in Lightroom, use Library's *Metadata > Export Keywords* to export it, and review the file's format in Notepad or TextEdit.

Finding and filtering

There's nothing stopping you from finding pictures by scrolling through the thumbnails and looking for those that meet your criteria. On the other hand, the more keywords, descriptions, and other metadata you've added to your pictures, the easier it becomes to find them by running text searches.

Lightroom is a database-powered program and searches for files by querying its catalog, in contrast to image browsers like Adobe Bridge that work through folders, examining their contents. This means that when your picture collection spreads across many subfolders, or to multiple drives, Lightroom is faster, by an order of magnitude, at finding photographs that match your criteria. With potentially many thousands of pictures in a single database, it's important to get up to speed with Lightroom's methods for finding and filtering.

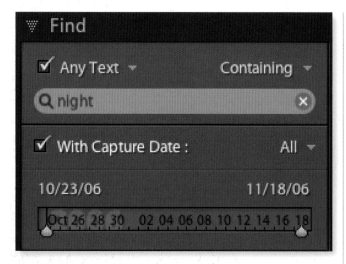

1 To run a metadata search, reveal the Find panel in Library's Left Panel (F7) and type a word. Typing in the word "night" makes Lightroom find any images whose metadata contains that word. Incidentally, searches are not case-sensitive.

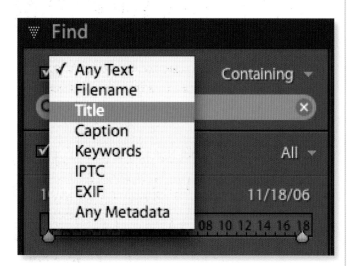

2 You can tell Lightroom which part of the metadata should be searched.

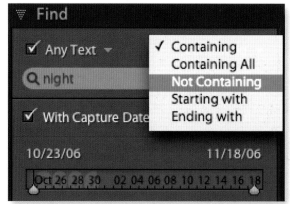

3 Tell Lightroom to look for pictures with metadata containing the text, or not containing it.

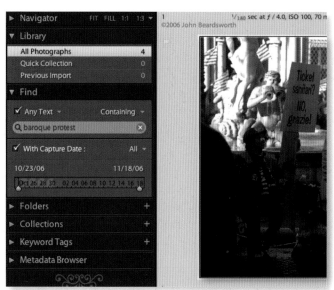

4 Typing in more than one word makes Lightroom look for any pictures whose metadata contains both words. Here, typing "baroque protest" has given me just those pictures where both words occur—in this case "baroque" being the style of the fountain around which this protest was happening.

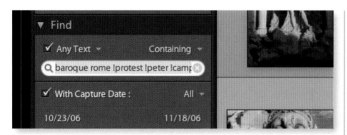

5 One useful trick is to use an exclamation mark (!) before a word. This excludes that word from the search—so here Lightroom will look for pictures with "baroque" and "Rome" in the metadata, but which don't contain "protest," "Peter," or "Campidoglio."

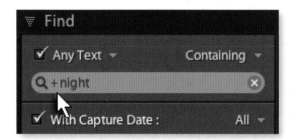

6 Adding a plus sign (+) before a word makes Lightroom apply the "begins with" rule for that word, while a plus sign after a word makes it apply the "ends with" rule. So "+night" makes Lightroom display nocturnal photographs, not pictures of the "Knight" family.

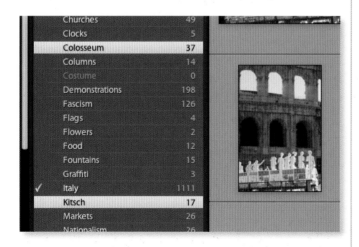

7 Clicking any item in the Left Panel makes Lightroom show the thumbnails of pictures in that category. Less obviously, you can select multiple items by holding down the Ctrl/⌘ key as you click items. Here in Keywords for example, Ctrl/⌘-clicking "Colosseum" and "Kitsch" has made Lightroom display all the pictures that contain either keyword. Some pictures have just "Colosseum," some just "Kitsch," and others contain both.

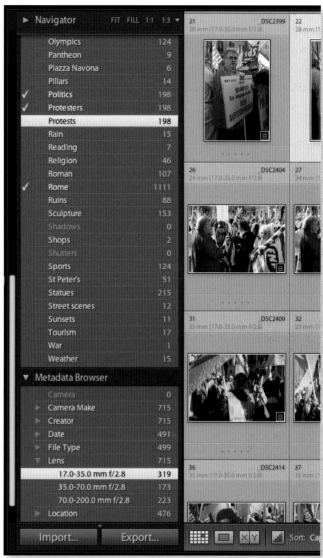

8 You can also Ctrl/⌘-click in different panels. Here I've clicked my wideangle zoom in the Metadata Browser, and Ctrl/⌘-clicked "Protests" in Keywords. Lightroom returns all the pictures of protests taken with wideangle zoom.

9 If you think you might want to find the same images again, save your find as a Collection with Ctrl/⌘+N.

Ratings

Ratings aren't new–browsers, cataloging programs and raw converters have always let photographers rate their images. Lightroom is no exception and its star-rating scale is a common approach. In fact it can read ratings that have been applied in Adobe Bridge and some other programs.

Before going on to see how to apply and use ratings, it's worth making a couple of general points. First, apply stars sparingly and avoid "ratings inflation," where so many images have four or five stars that you can no longer distinguish your best work. Second, be consistent. It'll be tough to narrow down your portfolio if one week you marked your best images with three stars and the next week you used four stars. Consistency is even more important to establish guidelines when you're working with colleagues.

Applying ratings

Lightroom's Library and Develop modules are the main modules where you can apply ratings. Choose between clicking the rating with the mouse, hitting the keyboard's number keys, and using the two bracket keys, [and].

1 In the Library's Grid view, use the mouse to click the dots at the thumbnail's bottom left. Here I gave this image two stars.

Set Rating to 2

2 In Library, reveal the metadata panel (F9) and click the dots next to the word Rating.

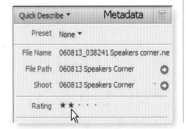

3 Press the number key. This works in Library and Develop, and also during a slideshow. Here I am in Develop, comparing my black-and-white version with the color original, and Lightroom briefly indicates that I have set its rating to 2.

Tip > Ratings

Rating	Most images
5 stars	My very best
4 stars	Special
3 stars	Worth showing
2 stars	Good
1 star	OK

Develop your own guidelines and apply them consistently. Avoid having too many images with the highest rating. Less than 1% of my pictures are in my highest-rated category.

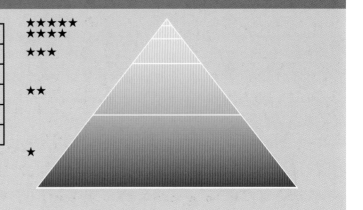

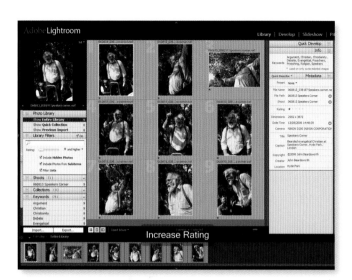

Increase Rating

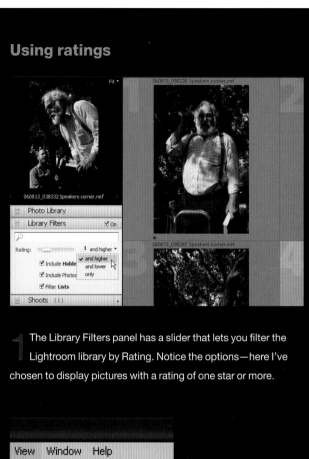

4 In Library or in Develop, use the brackets. These work just as they do in Photoshop, so [decreases the rating and] increases it. Here in Library I selected all nine pictures and increased the rating from 0 to 1.

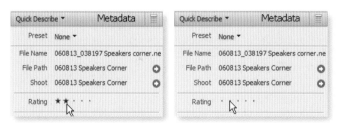

5 To remove all stars from a picture, go to Library and click the highest star to the right or press the number key 0.

6 Keep an eye on how many images are selected. Here the Filmstrip (F6) shows me I've selected the entire library. I might want to set them all to the same rating, or I may have to use Undo to reverse my mistake.

1 The Library Filters panel has a slider that lets you filter the Lightroom library by Rating. Notice the options—here I've chosen to display pictures with a rating of one star or more.

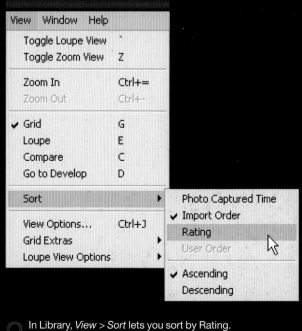

2 In Library, *View > Sort* lets you sort by Rating.

7 In Develop, you can also use the Shift key to apply a rating and advance to the next image.

Adding structure > Collections

Traditionally, if one can use that term in digital imaging, many photographers store their pictures in folders named to help them find pictures. This works best when search requirements are simple—so wedding photographers for instance are often satisfied with folders named simply by ceremony date. But more varied search criteria make "meaningful" folder structures a bit of a dead end. For example, imagine a stock photographer with a shot of a door in a Venice backstreet. Should it go in the Architecture/Italian/Doors/Doorknobs folder, or should it go in the Venice Locations folder tree? At the time the answer may be clear, but it's only after you spend an

hour looking for a particular image that you discover it's not too smart to rely on your folder names to categorize, describe, or locate pictures.

To avoid such problems, Lightroom's Collections are "virtual folders" that allow you to put some structure into the Library. So you could set up one Collection containing pictures relating to a project, and split them between shoots. Another Collection might be more short term—just the pictures you plan to burn to DVD and take to the printer, for example—and Collections are flexible enough to accommodate a family tree with pictures able to appear in more than one place in the structure.

If you ever find yourself copying files just to be sure, for example, that the doorknob picture is in the Doorknobs subfolder as well as the Venice Ghetto subfolder, stop yourself and think about Collections.

1 Building a Collection is similar to building a keyword hierarchy. Click the + sign in the Collections panel (F7) and add the main item's name. In this case I eventually want to break my Carnival shoot up by its individual subjects, so the first step is to add a Collection called Venice Carnival.

2 Then right-click your collection and add as many children as you need. Here I decided it would be easiest to start by splitting the shoot by mask type.

3 When your structure is ready, select items in Library's grid (G) and drag them onto the Collection or sub item.

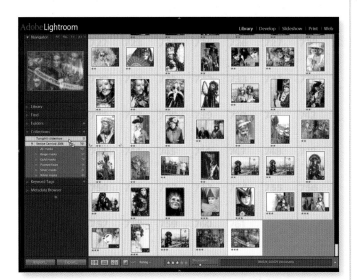

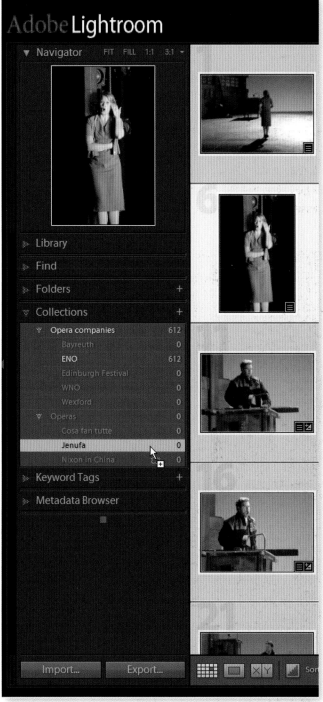

4 Photographs can belong to more than one collection. One reason might be to do a slideshow and show the best part of the shoot, so click the Collections panel and add the new Collection, then drag and drop the pictures onto it. Afterwards, I could delete "Tonight's slideshow" or leave it there just in case I want to re-run it. Collections can be temporary.

5 Another reason for using Collections is to analyze images by specific categories that are important to one's work. For someone who shoots multiple opera performances, for example, the Collections structure can be set up to find all the shoots by opera house, or by opera, and could be extended to cover performers, production style, etc. In this case, the Collections structure would be a permanent fixture.

Quick Collection

As you work through your pictures, evaluating and rating tens, maybe hundreds of images, you don't always want to apply permanent star ratings or colored labels. Often it's a case of picking a few shots, hiding the rest, and then working only on the ones you've selected. It's rather like working on a light table with a day's fresh slides, picking the ones to project after dinner, and pushing the rest to one side until tomorrow.

This is what Lightroom's Quick Collection feature is for. It's a very simple feature to use, and for sheer speed the best way to use it is to memorize its combination of keyboard shortcuts.

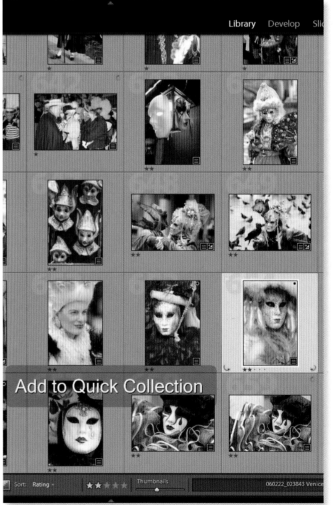

1 Clear any existing quick collection with the key combination Ctrl/⌘+Shift+B. Alternatively, use the menu option *File > Clear Quick Collection*. Notice how the quick collection is shown in the Library panel.

2 Review the images. When you want to add one to the quick collection, press B. Lightroom briefly shows "Add to Quick Collection" as an overlay.

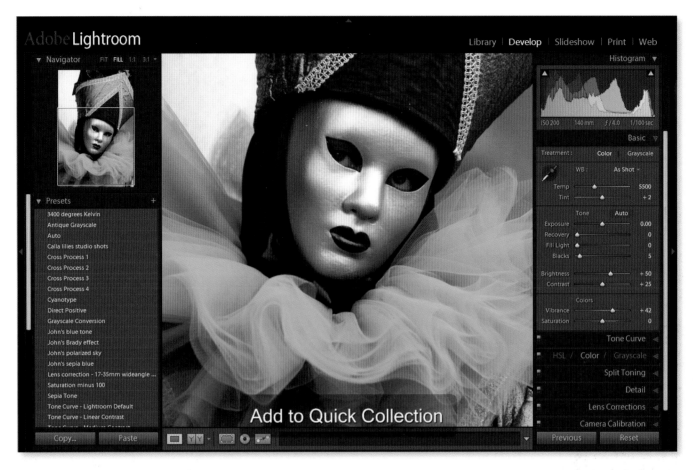

Add to Quick Collection

3 To remove a picture from the Quick Collection, press B again. Notice how you can add or remove items from the Quick Collection in the Develop module as well as in Library.

5 Quick Collections don't have to stay temporary. If you want to save the current items as a regular Collection, use Ctrl/⌘+Alt/⌥+B.

4 When you want to see only the Quick Collection, click Ctrl/⌘+B or go to *File > Show Quick Collection*. Alternatively, in the Library panel, click Quick Collection.

Tip > Shortcuts

	Windows	**Mac**
Add/Remove	B	B
Show	Ctrl+B	⌘+B
Save	Ctrl+Alt+B	⌘+⌥+B
Clear	Ctrl+Shift+B	⌘+Shift+B

Quick Develop > Why it's there and what it's for

It's easy to undervalue Lightroom's Quick Develop panel. At first it doesn't seem to belong in the Library, which is where you organize your work, add copyright, keywords, and other metadata, find pictures, and pick your selections. And its buttons appear limited and crude compared with Develop's precise sliders and controls. So I imagine many Lightroom users trying it once, and rarely using it again. That would be a mistake.

The more you use Lightroom, the more you should appreciate and exploit Quick Develop. First, it helps you make fair comparisons between differing exposures. Second, use it for "ballpark" adjustments so you spend less time in Develop. And third, use it to work in bulk.

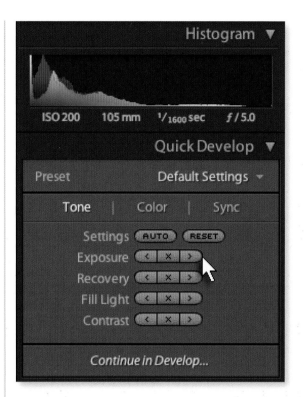

1 Photographers often choose to make exposures that don't look promising straight from the camera, but can be developed into their desired image. That's as true of digital as it was with film. But with modern cameras able to shoot many frames per second, how do you find the time to adjust each one individually or even identify whether any are worth keeping? That's a major reason why Quick Develop is in Library.

2 Exploit Library's Histogram. Here, the gap on the right is a sure sign of underexposure. To set the images' brightest tones to true whites, make sure they are selected and then click the Quick Develop's Exposure slider.

Strong sidelighting left me struggling to capture highlight details in this man's hair and face, so I underexposed by up to two stops. After bringing the shoot into Lightroom, it wasn't obvious whether there was anything worth keeping.

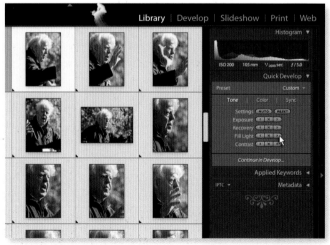

3 Each time you click Quick Develop's Exposure slider, Lightroom adjusts the exposure by a third of a stop. That's one difference between Library's Quick Develop and the Develop module—in Library adjustments are relative, while in Develop there are precise slider values.

4 When you forget to reset the camera's white balance, or just misjudge your settings, Quick Develop can be the best way to adjust the color temperature. You often only need to see the thumbnails to make your corrections—here, the thumbnails clearly show the street lighting's growing strength as night falls.

5 The earlier images need less cooling, if any. So I've selected the later ones, and clicked the white balance Cooler tool a few times.

6 At any point you can go over to Develop. Click the Continue in Develop button in Quick Develop, use the Ctrl/⌘+2 keyboard shortcut, or click Develop in the top panel (F5).

Quick Develop > Save yourself time

As well as revealing enough detail to enable you to compare and evaluate a series of shots, the second major reason for using Quick Develop is that it can save you a lot of time working in Develop.

Lightroom's Library is geared towards speed, while Develop's fuller range of sliders and controls are more suitable for fine-tuning. Unlike in Develop, where the original image data is used, in Library and Quick Develop your pictures are displayed quickly because Lightroom uses cached renditions, basically **JPEGs** that it created

when the images were imported or that it saves in the background as you work. Quick Develop editing adjustments also appear more quickly because the editing commands are relative and incremental, not setting precise values like Develop's sliders. So for some purposes, such as proofing, Quick Develop's broad adjustments might be all you need for a shoot, and all you have time to do. In other cases, they can get you so close to the finished product that you need do little more than adding the finishing touches in Develop.

1 You can adjust images at the same time as you compare and evaluate them side by side. Select the images in Library's Thumbnails view and click the Compare button.

2 Selecting the best picture from a heavily bracketed sequence can be awkward without first adjusting them closer to their final state. So, without leaving Library, click Quick Develop's sliders.

48

5 When you want to reset a value, click the cross between the two arrows.

3 Adjust the sliders as much as you need. Here, the overexposed image on the right was darkened by clicking Exposure's left arrow four times.

4 It's important to remember that Quick Develop adjustments are relative, not precise like Develop sliders, so the white point changes by a third of a stop each time you click the Exposure arrow, or the Fill Light slider moves in increments of five each time it is clicked. When you're finding your feet with Lightroom, it can help to click an arrow and then go into Develop and see its effect. Here, step 3's Exposure adjustment shows as -1.33 in Develop's Basic panel (F7).

Quick Develop can often get you really close to the final image, and the more you use Lightroom, the more true this becomes. After darkening this overexposed shot with four clicks of the Exposure arrow, I only needed Develop to apply the final crop.

Quick Develop > Batch conversion

Lightroom assumes you often need to adjust dozens, sometimes hundreds of photographs, and you simply won't have time to process each one individually. Directly accessing raw data, which is what Lightroom does in the Develop module, demands a lot of the computer's resources and isn't practical for handling images in bulk. The Library module is powered by cached versions of your pictures, which greatly speeds up screen redrawing and other activity, and so batch processing is the third major task you will do with Quick Develop.

 We've seen how the Library's Left Panel (F7) helps you filter your pictures so you have on screen only those you want. In Library's Grid view (G) it's also much easier to select individual thumbnails, and review those selections, than in the Filmstrip you have in Develop. You then have a variety of ways to adjust your work. After clicking Quick Develop's arrows, or applying a preset, you can often go straight to exporting the finished pictures. Alternatively, you might fine-tune a single shot in Develop and then use Quick Develop's Sync button to pass those adjustments to the rest of the shoot.

Develop, Export, and Undo

It's hard to beat Quick Develop when you want to generate large numbers of proofs, for instance rendering an entire shoot as black-and-white JPEG files. With a few keyboard shortcuts, you can do this sort of work at breakneck speed.

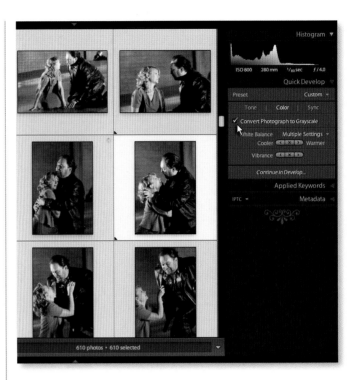

2 Press F7 for Quick Develop, tick Grayscale, and Lightroom will immediately start updating all the images.

1 Press F6 to reveal Library's Left Panel (F7), set the filters to identify the images you want to adjust, and press Ctrl/⌘ A to select them all in Grid (G) view. Notice how the toolbar shows I've selected all 610 images.

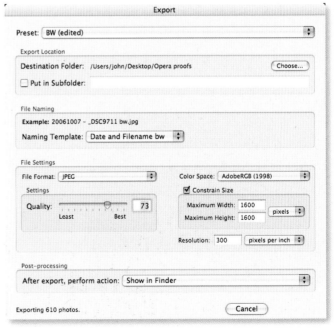

3 You can now export the images, even if in the background Lightroom is still applying the Grayscale adjustment. With the pictures still selected, press Ctrl/⌘+Shift+E to open up the Export dialog box, choose an output destination, set the other export choices, and click Export.

50

4 If you don't want to leave the pictures as black and white, just select Undo or Ctrl/⌘+Z, and Lightroom will start reverting to their condition before step 1 while the Export continues in the background.

Apply Presets

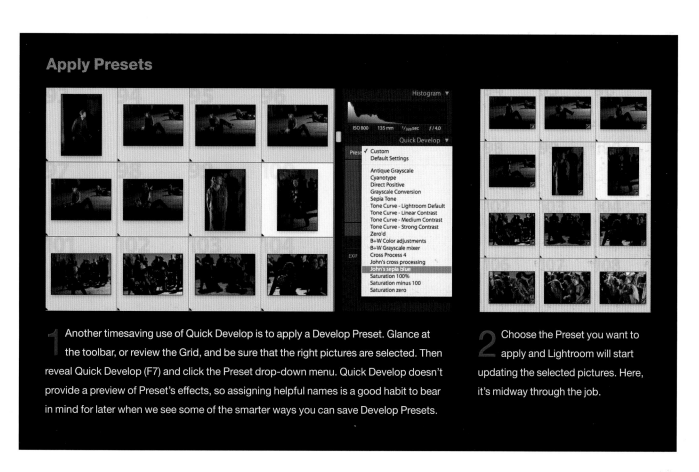

1 Another timesaving use of Quick Develop is to apply a Develop Preset. Glance at the toolbar, or review the Grid, and be sure that the right pictures are selected. Then reveal Quick Develop (F7) and click the Preset drop-down menu. Quick Develop doesn't provide a preview of Preset's effects, so assigning helpful names is a good habit to bear in mind for later when we see some of the smarter ways you can save Develop Presets.

2 Choose the Preset you want to apply and Lightroom will start updating the selected pictures. Here, it's midway through the job.

51

Synchronizing

Occasions will often arise when you need to copy adjustments from one image to the rest of a sequence. You may have used Quick Develop to adjust some pictures, but overlooked some other frames that need the same corrections. Or you may have processed an outstanding shot in Develop as soon as Lightroom had imported the shoot, and then find you need to apply the treatment to the others. When you are processing so many images, you need a number of different ways to copy settings between pictures.

Whether you've stayed in Library and used Quick Develop, or gone to Develop for fine-tuning, Library is one of the best places to replicate those adjustments on other images. Its Grid (G) is the easiest place to select pictures and, just as importantly, to feel confident you've selected just the right ones. And Quick Develop also contains Sync.

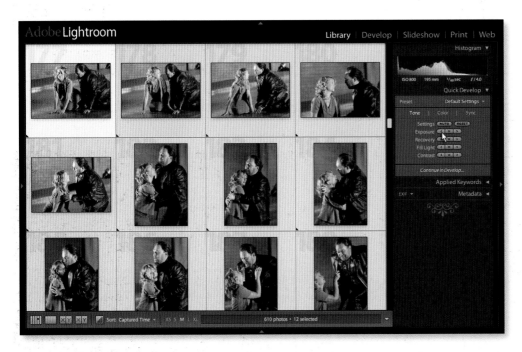

1 This series of opera shots seemed a little overexposed and slightly too warm. You can fix such things in Quick Develop.

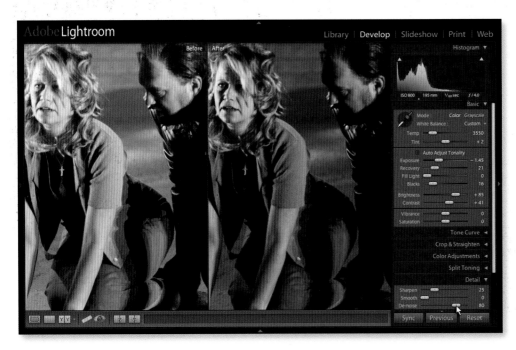

2 Alternatively, adjust the best image more carefully in Develop. Here I felt unsure about the color temperature and wanted to sample image areas with Develop's White Balance tool. Also, the shoot was all at ISO 800 or more and I needed to use Develop's Detail panel to limit the digital noise.

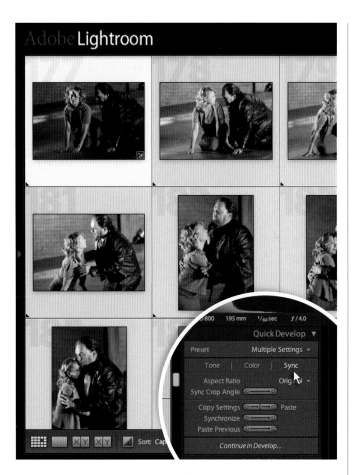

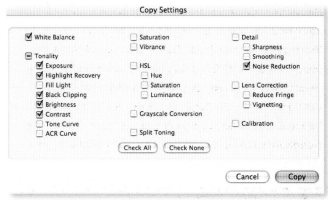

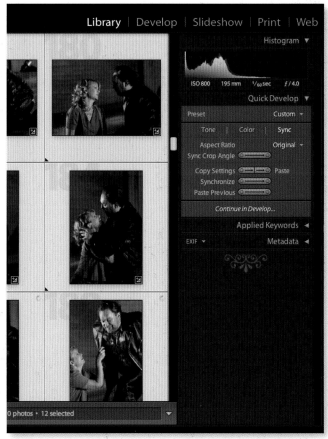

5 Usually it's better to click Check None and select only those adjustments you want to copy to all the pictures. This prevents the Sync operation from overwriting any existing adjustments that might relate to individual shots.

3 When your adjustment work is done, go back to Library's Grid and check you've selected only the pictures you want to adjust. Also check that the image you've worked on is "most selected"—here you can see it's brighter than the rest. Then click Sync in the Quick Develop panel.

4 The Synchronize Settings dialog, like the similar Develop Presets dialog, lets you choose which adjustments to copy from the "most selected" image. In this case it was the first time I'd worked on these pictures, so it was safe to click Check All.

6 In the Synchronize Settings dialog, click Synchronize and your adjustments will then be passed to the other selected pictures. Here, Lightroom has almost finished applying the changes, so I've been able to fine-tune one image in Develop and then quickly send those changes to the rest of the sequence.

Export > Creating output

After you've adjusted your pictures in Lightroom, there's no need to save your work. You can close the program, open it again, and the pictures still show the changes you applied previously. At this point you have no end product, other than being able to see the adjusted images on screen. How can you get those files in front of someone who doesn't have Lightroom?

This is one of the most striking differences between Lightroom and Photoshop. Each time you process a file with Photoshop or another bitmap editor, you have to save an output file or you will lose your work. By contrast, Lightroom records your editing instructions in its database as you work. It then recalls this information and processes the images only later when you instruct it to output JPEG or TIF derivatives, create prints, or generate web output. The process of outputting these derivative files is known as Export.

1 Select the images you want to edit in Lightroom's Library. Here is a Quick Collection of six adjusted raw files, but we could easily be talking hundreds or thousands of shots.

2 You can also export files by selecting them in the Filmstrip (F6), which is visible in modules other than Library. This may not be as easy as using the Library and its Grid view, especially with lots of pictures and when some are selected and others aren't. But it may be convenient at times, as it was here since I didn't need to leave Develop after fine-tuning one of the images from my Quick Collection.

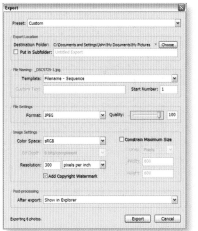

3 With the items selected, either in Library or in the Filmstrip, choose File > Export or use the keyboard shortcut Ctrl/⌘+Shift+E.

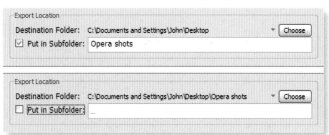

4 Be careful to specify exactly where you tell Lightroom to save the exported files. For one thing, it's very easy to export to a folder and then forget where it is. Secondly, it's best to be specific about the folder. Here both Export locations will work, and send files to Opera Shots on my Windows Desktop. But the top example is a bit riskier—if I carelessly unticked Put in Subfolder, Lightroom would send all my export files to the Desktop. I'm sure you can imagine the mess if I did this with more than six shots.

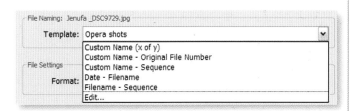

5 From the Export dialog's File Naming drop-down menu, choose an existing preset or select Edit and create your own.

6 For a very simple renaming template, I typed in the opera's name, a space, clicked the Filename button, and then selected Save as New Preset from the Presets drop-down menu.

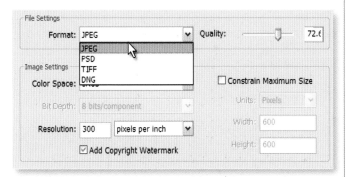

7 When you choose the output file format, Lightroom presents you with relevant choices. If I'd chosen TIF or PSD, I would see choices for bit depth, compression, and Color Space. Here I selected JPEG, so I can reduce the quality a touch and output compressed files.

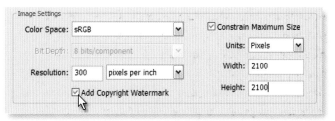

8 To limit the physical dimensions of the output files, tick Constrain Maximum Size. Here my shots are all portrait format, so the height will be the limiting factor. Notice I also ticked Add Copyright Watermark so that the images will be marked with the contents of the Copyright metadata.

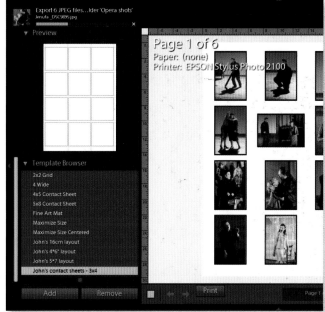

9 As soon as you press Export, Lightroom starts creating the output files. It's important to remember that this happens in the background, so you can carry on with your work. You no longer need to keep the images selected and can change module or even set off another Export task. Notice here how the Export is running, shown by the progress bar at the top left, and I've added some other pictures to my selection and jumped to Print.

Tip > Save your settings

When a dialog box like Export offers a preset option, always consider saving your settings—it's so quick and can save so much time.

Quick contact sheets

Neither digital photography nor web photo galleries have killed off the contact sheet. Clients still demand them and many photographers continue to see hard copies as a powerful selling tool.

Digital promised a way forward by automating the process–though the reality rarely matched the heightened expectations. It's not acceptable to trade off quality against speed, and processing hundreds of raw files isn't a small task. Photoshop can batch-process a shoot into contact sheets, locking up your computer while it opens one raw file at a time. There are also many cataloging programs, certain image browsers, and dedicated utilities which have all found their advocates.

Lightroom offers a pretty compelling solution to the problem of contact sheets–select the thumbnails, choose your template, and hit Print.

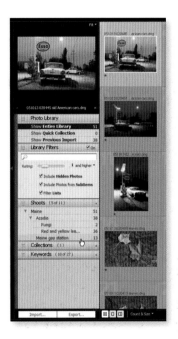

1 Library is often the best starting point for a contact sheet. Click Shoots, Collections and use filters to narrow down your pictures to those you want to include. Here I set the Filters panel to show shots with a rating of one or higher and then clicked a small shoot taken one evening in rural Maine.

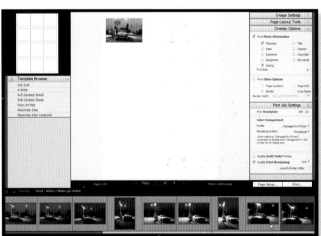

2 Now go to Print. Unless you have selected the thumbnails in Library, you may well see just one image displayed on the grid. So display the Filmstrip (F6) and use the mouse to select all the items you want on your contact sheet.

3 Make sure the Left Panel (F7) is open and move your mouse over the Template Browser. As the cursor passes over the template names, Lightroom shows a small preview. Click the template that looks the most suitable. Here I selected the built-in template with four columns and five rows.

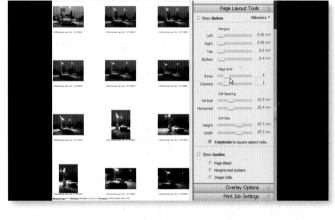

4 To make best use of the page, change the grid. Display the Page Layout Tools (F8) and drag the Page Grid's two sliders, Row and Column. Here a 4 x 3 grid obviously makes most sense.

5 Below the contact sheet's preview, Lightroom shows you how many pages will be printed. You can click the arrows to move through the print run, or use Page Up/‡ and Page Down/ ‡.

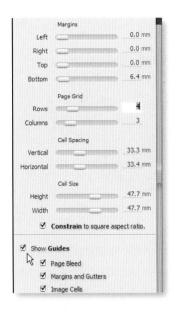

6 Another tip is to tick Show Guides, which is at the bottom of Page Layout Tools (F8). If your contact sheet is like mine and contains too much white space, the grid's cell sizes and spacing will quickly show you what you need to fix.

7 If you like to work precisely, Page Layout Tools (F8) can display a ruler and allows you to switch its unit of measure. This also has the shortcut Ctrl/⌘+R.

8 As you drag the Cell Spacing sliders, Lightroom adjusts the Cell Size. You can also type the spacing manually.

9 To display information about your pictures, go to Overlay Options in Print's Page Layout Tools (F8) and tick the options you want.

10 It can be a nice touch to add borders, especially when some thumbnails have bright areas close to their edges. Overlay Options has a checkbox and a slider to let you change the border width.

11 Pause before printing your contact sheet and save the templates. Even if you never use this one again, getting into this habit will save time in the long run.

Template Browser
- 2x2 Grid
- 4 Wide
- 4x5 Contact Sheet
- 5x8 Contact Sheet
- Fine Art Mat
- Maximize Size
- Maximize Size Centered
- John's contact sheets - 3x4

Slideshow

Slideshows are obviously a great tool for selling and presenting your pictures. Lightroom's Slideshow is probably its most straightforward module, and a little experimentation is all you need to produce a professional slideshow. Obviously that simplicity is welcome when you're showing pictures face to face with a customer.

Preparation is very important for a slideshow, so start by saving your chosen pictures to a Collection. Then either go directly to Slideshow, especially if you want to alter some of your settings, or stay in Library, select the required thumbnails, and choose *Library > Impromptu Slideshow*–this starts the presentation using the Slideshow module's current settings. Starting a slideshow in Library can also give the evaluation process a more relaxing, contemplative mood.

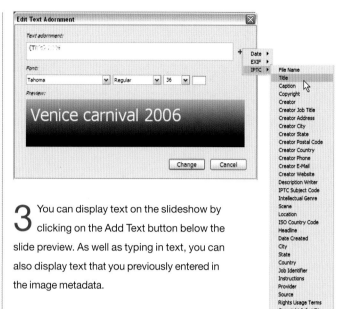

3 You can display text on the slideshow by clicking on the Add Text button below the slide preview. As well as typing in text, you can also display text that you previously entered in the image metadata.

1 Consider creating a new Collection to save the images you want to include in your slideshow. One way is to create a top-level Collection—such as "John's slideshows," shown here—and then use it as a container for individual slideshows.

2 One big advantage of a Collection is that when you select it, you also hide images you don't want in the slideshow. Click your Collection, such as my "Red rose," and then enter Slideshow. If you're already in Slideshow, reveal the Filmstrip (F6), and you will see that it only includes the Collection.

4 If you want to temporarily hide the text boxes, uncheck Show Custom Objects in the Right Panel's Overlay Options.

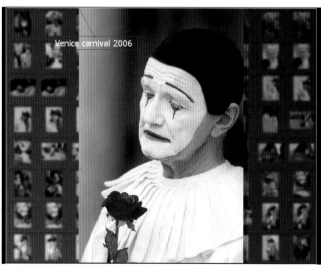

5 To position the text, drag it around the slide preview area. An anchor line shows how the text will appear, and links automatically to a position on the photograph edge (corners or midpoints).

6 Always check your text box's position with portrait and landscape format images. This is the text I added in step 3—I'm going to have to drag it into position.

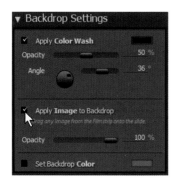

7 To add a custom background image, tick the Apply Image to Backdrop checkbox in the right panel's Backdrop Settings. Then drag an image from the Filmstrip (F6) into the slide preview area.

8 You can use any type of graphic as a background, not just a photograph. Just import the graphics into Lightroom—keep them together in a separate Shoot or Collection such as "My Wallpaper." Here I made the images in Photoshop, one with the program's Clouds filter and a copyright symbol, and the other by blurring a screen grab of Lightroom thumbnails.

9 I keep emphasizing the importance of saving templates, but it's such a good habit, costs you 10 seconds, and will often save you time.

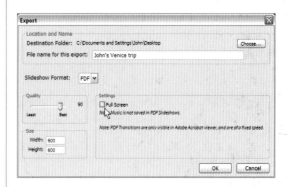

10 If you need to send your slideshow to someone, *File > Export* saves it as an Adobe Acrobat PDF file which can be viewed in Acrobat Reader (in future versions you be able to save in other formats, too). Be careful with the output size. Here my 600-pixel setting will mean that, unless the viewer's screen is very small, Acrobat Reader will stretch the images to full screen and cause pixellation.

11 Lights Out mode is a good way to preview the slideshow and still be able to adjust the settings. Here I quickly hit the F5, F6, F7, and L keys, leaving just the Right Panel visible.

Web galleries

High-speed internet access is readily available these days, and web galleries are an increasingly practical way to distribute proofs of newly annotated and edited shoots. Clients can quickly see online contact sheets, while photographers can greatly reduce printing and distribution costs. But it's an individual choice and some people prefer printed contact sheets.

If you are not concerned about potential misuse of electronic images, Lightroom's Web module can create professional web contact sheets and can even upload them to your web space. These web galleries consist of HTML pages of thumbnails which are linked to other pages with individual, larger-sized images. Try to test the output site in different browsers and if possible on both Mac and PC. This is because Lightroom's built-in templates use relatively modern web features (XHTML and CSS) and you must be sure your web pages display properly on the viewer's computer, not just yours.

1 In Library, check your pictures all contain your copyright and contact information and any other metadata that you consider important. A quick way is to use the keyboard shortcut J to cycle through the thumbnail views and show the expanded information. Then right-click one of the labels and select the field you want to check. Here I added Copyright from the context menu.

2 Save the images for your web contact sheet as a Collection. Realistically, you often notice typos and other errors only when you review the final HTML output, so people often generate a web contact sheet more than once. A well-named collection can save you work.

3 Click your Collection and activate the Web module. If you decide to change the items that will appear in the web contact sheet, you can always display the Filmstrip (F6) and Ctrl/⌘-click items you want to deselect.

4 To choose the gallery's appearance, select a template either from the Left Panel's Web Presets (F7) or from the Right Panel's Gallery Style drop-down menu.

5 Work your way down the Custom Settings panel (F8) and add any text you want to display on the thumbnail pages, change any colors, and set the number of rows and columns for each page.

6 Set the maximum size of images that will go online by dragging the slider or by typing in your chosen value. Don't make it too big— I recommend anything between 450 and 800 pixels.

7 To see the appearance of the individual pages that display the larger images, click one of thumbnails in the central preview area. Change the text on these pages in the Image Settings panel. You can type words in directly, or use the drop-down menu to pick text that you may have already entered in Library. Here I added the IPTC title to my pages.

8 As always, consider saving a Web Preset. In the Left Panel, click the Add button, and Lightroom will store your web gallery titles and any other settings. Just like saving a Collection, this could save you time later.

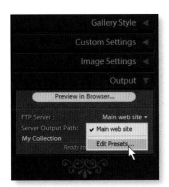

9 To upload your web contact sheets to your web space, you can click the Save button and save the web gallery in a folder on your computer, and then upload it with another FTP client. But Lightroom can also upload files directly—first set up an FTP preset in the Output Panel by clicking the FTP Server drop-down box.

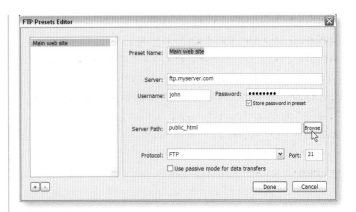

10 You should consult your web hosting documentation for details of your web space's FTP address. This is usually shown in a format similar to that shown here. The Server Path should also be documented by your web hosting service. These detailed addresses vary widely and you will need to enter them exactly, so ask your web host or a friendly web designer for assistance if you have trouble connecting to your web space. When you have entered these details correctly, you can check they are correct by clicking the Browse button, which examines your web space. Then click Upload and Lightroom will generate the site and upload it to the server.

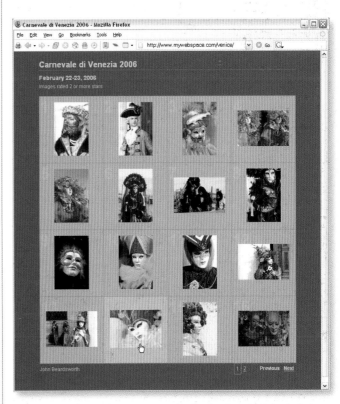

Lightroom's Web module can create professional web contact sheets that meet most requirements. Make sure you check their appearance in a number of web browsers.

Building the brand > The Identity Plate

Putting your name and logo on contact sheets and web output is a basic requirement. It's also easy to imagine Lightroom being used directly in front of a customer, a newly married couple choosing their wedding album or a client's art director present in the studio during a tethered product shoot.

Adobe's design team understood the marketing and branding needs, and also that photographers would expect Lightroom to look good as well as provide the tools to do the job. Lightroom's solution is called the Identity Plate.

At the top of the Lightroom window, the Module Picker panel contains space for corporate branding. You can replace the Adobe Lightroom logo with your own.

Changing the Identity Plate

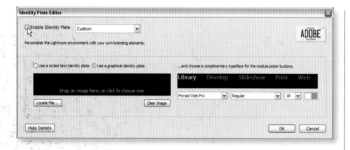

1 Change the Identity Plate in *Edit > Identity Plate Setup*. Make sure Enable Identity Plate is ticked.

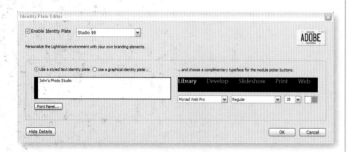

2 One option is to add some simple text. This can be in the typeface and size of your choice.

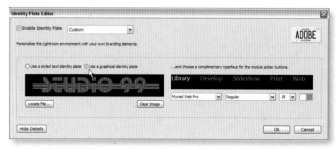

3 Personalization can go much farther—you can also use a graphic such as your studio or company logo. Check the Use a graphical identity plate option and browse to a graphic such as this fictional logo I prepared in Photoshop.

4 The graphic should be a JPEG or GIF file, or PNG or BMP if those formats are more convenient. Though you may already have a suitable image such as a web site logo, it may be better to prepare one in Photoshop or another image editor. The graphic will need to be 48 pixels high, but it can be wider than the built-in Adobe Lightroom logo in the Module Picker panel. Here I used a screenshot to make a graphic that was specifically for this set of pictures.

5 To remove the Identity Plate, go to *Edit > Identity Plate Setup* and uncheck the Enable Identity Plate box.

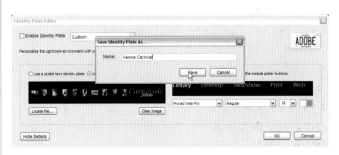

6 You may only need one Identity Plate, but save it nonetheless.

Using the Identity Plate

1 The Identity Plate is visible whenever the Module Picker Panel (F5) is visible. Here it is in Develop.

3 You can include it on your web gallery output, similarly by enabling it in the right-hand panel. You can also attach any link to it, though by default it points to the index page of your web gallery.

4 Print, too, has an overlay palette from where you can choose to print it alongside, or above, your images.

2 You can display it on a slideshow by turning it on in the Overlays palette (in the right-hand panel)

Develop > Processing your work

Develop is the heart of Lightroom and is where Adobe's image-processing skills and experience give it a leading edge. Behind the scenes, Lightroom takes advantage of the Adobe Camera Raw engine that has processed raw files since Photoshop version 7. This engine has never stood still—each time the camera manufacturers change the proprietary format of their raw files, Adobe responds by releasing a new revision of Adobe Camera Raw. So you've never had to wait for a new version of Photoshop before your new camera is supported, and that will be true of Lightroom too.

Lightroom uses the latest version of Adobe Camera Raw. The engine is still shared with Photoshop, but Lightroom has extra tools and controls that can make Adobe Camera Raw produce even better conversions of your raw files. New sliders, such as Fill Light, significantly reduce any need to process files through Photoshop. And Lightroom also processes JPEG, PSD, and TIFF files using the same interface as you use to process raw files.

While Lightroom's underlying processing is the same, there's a big difference between how Quick Develop and Develop apply adjustments. Quick Develop adjustments affect all the pictures you have currently selected, while in Develop they only apply to the image you are currently editing—the "most selected" item. So multiple image editing in Develop is a two-step process—first you fine-tune one image, then you display the Filmstrip (F6), check the right pictures are selected, and click Sync.

Develop workflow

Lightroom is all about processing large numbers of photographs, and that often means working under varying degrees of time pressure. Expect a much less leisurely pace of work than when you're perfecting an individual image in Photoshop, when even the experts proceed in a considered fashion—and, according to Adobe designers, rarely exploit more than a small fraction, maybe 20%, of Photoshop's numerous features. Lightroom, on the other hand, is much more focussed and has a far smaller, but highly dedicated, set of tools. The Lightroom expert works at speed—it's

the difference between a darkroom printer and the busy professional lab.

That lab's 24/7 production-line mentality is how I'd like you to imagine your experience working with Lightroom. But over the next few pages it's my aim to make that prospect much less daunting. With practice, the Lightroom workflow can be every bit as fluid as changing aperture, ISO, exposure compensation, and all the things you do without thinking while blazing away with your many-frames-per-second camera.

The first step to optimizing your Lightroom workflow is to use Library's Quick Develop panel properly—that is, as much as you can. Before going into Develop, you should already have used Library's Quick Develop on the bulk of the shoot and made enough adjustments to evaluate your pictures fairly and pick out the best. So don't skimp on Quick Develop—the adjustments may be rough thirds of a stop or percentage changes, but at the very least your pictures should be "in the ballpark" for fine-tuning in Develop.

When you shoot large numbers of pictures, at a wedding for example, you'll be much more productive if you use Quick Develop as much as you can. A single click can adjust the white balance of hundreds of pictures.

The second step is to try to split your Develop work into three phases. Start by working "zoomed out" and make global adjustments like white balance, exposure, and tone while viewing the entire picture. Next follows a series of "zoomed in" tasks where it's absolutely vital you look at the pixels—jobs like dealing with digital noise and dust spots. Finally, copy those editing adjustments to the other shots in the sequence, and think about saving yourself time in the future by saving the adjustments as a Preset.

Phase 1 > Zoomed Out

First deal with overall image adjustments like correcting the white balance, saving a version, straightening and cropping, setting the white and black end points, recovering the highlights, setting the shadow areas, and adjusting the tone curve. These tasks are generally done best with the full image on screen, so zoom out with Ctrl/⌘+⊖, or click the Navigator's Fit button.

At times you may have to zoom in on key details, but tasks like cropping need the whole image on screen.

Phase 2 > Zoomed In

Once you've adjusted the entire image, then zoom right in with Ctrl/⌘+⊕, the Navigator, or by clicking a point with the mouse. You need to see the pixels to do a good job of dealing with digital noise, dust posts, lens fringing (chromatic aberration) or capture sharpening.

To deal with noise, you must zoom in. Here I dragged the noise slider to the left so I can see both the color and the luminance noise.

Phase 3 > Multiple Images

After the zoomed out and zoomed in tasks, apply your editing adjustments to the other shots in the sequence. Press F6 to reveal the Filmstrip—it shows you which pictures are selected and uses a lighter background for the "most selected" image, the one you are currently editing.

At this point you should be thinking about multiple images and about your productivity. So press Sync to apply your editing adjustments to the other images in the sequence, and quickly ask yourself if saving a new Preset would be a timesaver in the future.

In the Filmstrip (F6), the current image has a lighter background. Sync adjustments to the others, and consider saving a new Preset.

All the while as you move through these three phases, picture yourself continually using the F5, F6, and F7 keys to hide and display the tools you need. Whenever you need to, split the screen into Before and After comparisons, and then switch back to normal. And try holding down the Alt/⌥ key whenever you drag any slider. At first doing all these things at once may seem as unnatural as rubbing your stomach and patting yourself on the head at the same time, but soon it'll be as automatic as everything you do in those moments before you release the shutter.

Whether you're in the zoomed out or zoomed in phase, Split Screen shows you the progress of your editing work. Notice how I've also quickly pressed F5, F6, and F7 and hidden all the panels at the top, bottom, and left.

Straightening and cropping

Not getting the scene or the horizon level is one of the most jarring and—given your skill with the camera—the most surprising faults you ever have with a picture. So straightening it is often one of the first things you want to do. It also makes sense in Lightroom's workflow to make the correction early in the editing process, and to save a checkpoint. Every new version you make of the picture can then begin from the straightened version.

Cropping can happen at any time in the workflow. A photograph may not attract the eye or merit further work without it, or the crop may be a crucial finishing touch. In Photoshop it's often best left until the end, because cropping removes the discarded pixels from the file. However, a metadata-driven editor like Lightroom has the advantage that you can adjust the crop at any time. You can try experimental crops, make a series of editing adjustments, and then just as easily restore the entire frame. And the more freely you can experiment with alternative crops, the more likely you are to discover one that really suits the picture.

1 Lightroom's Crop and Straightening tool is a combined tool. Press R to activate it, and a second time to apply the crop and exit Crop mode. Or click the tool in the Toolbar (T). The Crop Overlay should appear over the image.

2 The easiest way to straighten a picture is to hold down the Ctrl/⌘ key. The cursor changes into Straightening tool mode— a line with dots at each end—and you drag along something that should be straight, like the horizon or the lighthouse wall. As soon as you release the mouse button, the image rotates. Sometimes you have to try again, but this way is very quick and easy.

3 Alternatively, move the cursor outside one corner. The cursor changes into a rounded, two-headed arrow and you can then drag and rotate the image. Lightroom temporarily adds a grid to the image which helps you with precise alignment.

4 To crop one side, move the cursor over an edge and wait till it changes shape into a two-headed arrow. Drag the edge to crop just that side of the image.

5 To crop two sides of the picture at once, move the cursor over the corner and wait for it to change shape into a crossed, two-headed arrow. Again drag inward and outward.

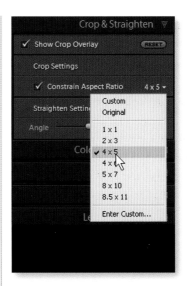

7 To constrain the crop shape to certain proportions, reveal the Right Panel (F8) and go to the Crop & Straighten panel. Notice how this panel gives you another way to activate the Crop Overlay and a slider for precise image rotation.

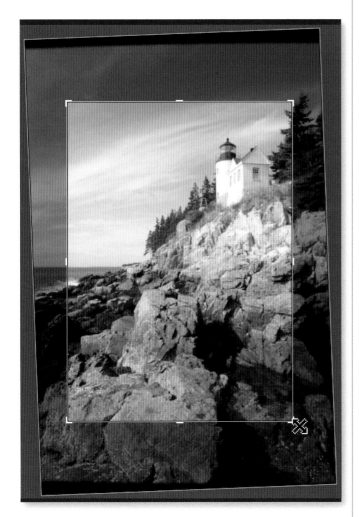

6 Just like in Photoshop, dragging and holding the Alt/⌥ key makes both sides of the image move at the same time.

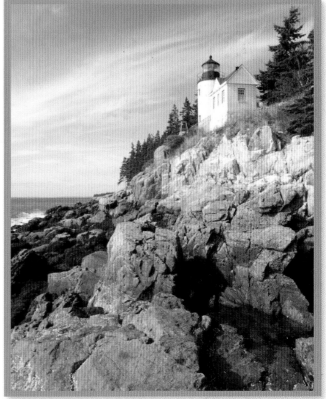

The final image is straightened and cropped to a 4:5 shape.

Tip > Correcting perspective

Lightroom 1.0 can't do perspective corrections so if your image is spoiled by converging verticals, that's a job for Photoshop.

White balance correction

For the majority of photographers, digital capture has made controlling white balance much more flexible than it ever was with color-control filters and daylight and tungsten film. The automatic settings on digital cameras are increasingly accurate–some even let you dial in precise color temperature readings from handheld meters. And of course those who shoot in raw can always fix the white balance later.

As with straightening, it can make a lot of sense to correct the white balance early in the editing process. Lightroom reads the white balance values you set in the camera, but if those values look wrong it's very simple to switch to another color temperature. You can select a preset value, drag color temperature sliders, and judge by eye, and the White Balance tool (W) lets you click and sample image objects that you know are a neutral color.

1 If you need to adjust many images at a time, use Quick Develop. Switch the Library to the thumbnails view, and select the pictures. Then just choose a preset value from Quick Develop's drop-down menu.

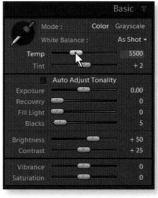

2 Switch to Develop for more precise control. In the Right panel (F8), go to the Basic panel and drag the white-balance sliders until you are happy with the image's warmth or coldness. To reset a slider, double-click its center.

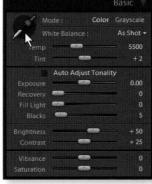

3 You can also key in the numbers directly. The arrow keys also work in these boxes—Up and Down move the Temp slider in increments of 50, or 200 if you also hold down Shift. If you've used color-correction filters with film, remember that here you are keying in the color temperature of the original scene, not the temperature of the final result.

Tip > In Quick Develop

In Quick Develop you can also click the Warmer or Cooler buttons. This nudges the color temperature adjustment.

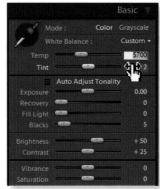

4 While the sliders work well and are very precise, the White Balance tool is my favorite way of setting the image's color temperature. Click the tool in the Basic panel, or press W.

5 Now click an object in the picture that you know was neutral, and Lightroom will use it to balance the color temperature of the whole image. Here I knew the church façade was a neutral color and chose it for my sample.

6 You frequently need to sample more than one image area before the picture has the most pleasing or accurate color temperature. In this case I thought I remembered that the costume was black, but it could easily have been a very deep brown. In fact this illustrates how it's often best to sample a mid to lighter tone, not a pure white or obscure dark tone. Notice too how I zoomed in while using the White Balance tool.

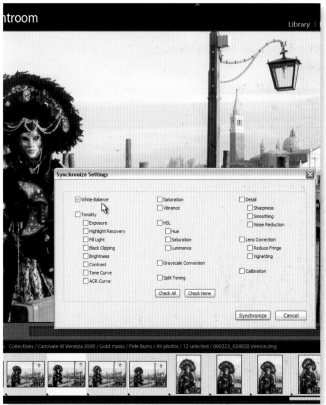

7 Once you are satisfied you have corrected the current image's white balance, apply it to the other images from the sequence. Display the Filmstrip and check the correct pictures are selected— notice how the current image's background shows it is the active or "most selected" one. Then click the Sync button, select White Balance, and click Synchronize.

The correct white balance was taken by sampling the church façade. While this process has cooled it a little, the picture was taken on a late February afternoon, so I've left it quite warm.

The Exposure slider

Unlike Quick Develop, which displays thumbnails and previews from Lightroom's cache, Develop works with the original image data. This means that it shows a wealth of information about the picture's characteristics, and provides a set of precise tools to enable you to finely control its development.

Over the next few pages we'll look at Develop's Basic panel and a group of four sliders which together are the key to producing the best possible work from Lightroom. Each is important on its own, so it is best to focus on each individually, but they do overlap and work collectively (see box below).

Tip > **Develop's Basic panel**

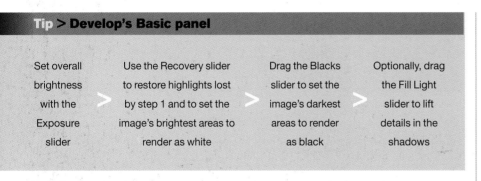

| Set overall brightness with the Exposure slider | > | Use the Recovery slider to restore highlights lost by step 1 and to set the image's brightest areas to render as white | > | Drag the Blacks slider to set the image's darkest areas to render as black | > | Optionally, drag the Fill Light slider to lift details in the shadows |

2 Assess the image by glancing at the Histogram. Just like on your camera, a spike at one end of the chart tells you a channel is clipped or shows no detail. Here a white spike at the right means all three channels are clipped, and the gap to the histogram's left shows that the image currently has no true blacks.

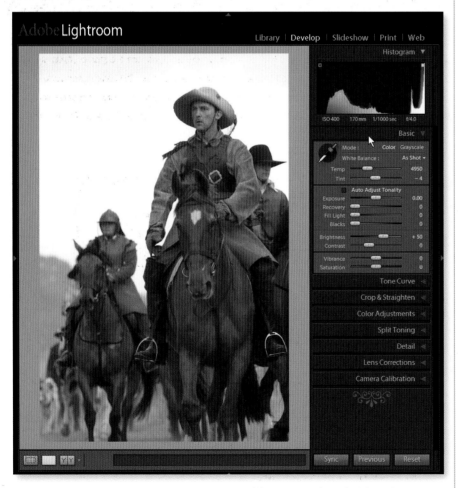

3 To see which parts of an image are clipped, position the cursor over the Histogram's highlight indicator square or press your P on your keyboard. While the cursor is hovering over the square, clipped highlights are shown in red and blocked shadows in blue.

1 Reveal the Right Panel (F8) and display the Basic panel. Hold down the Alt/⌥ key and click the panel's header—this closes other panels and reduces the amount of scrolling.

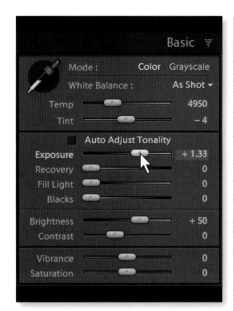

4 Now drag the Exposure slider and notice the effect on the image while glancing occasionally at the Histogram. While you should concentrate on the image's brightness and overall appearance, try to put to one side what Exposure is doing to the highlights and the blacks. To some extent, you can sort these out later. For now, just concentrate on the overall image.

6 You can see your work's effect on clipping in real time. Hold down the Alt/⌥ key as you drag the Exposure slider. Hold Alt/⌥ for a moment, drag, assess the results, then release it. Lightroom shows unclipped areas as black, but white areas indicate I have burnt out the highlights. Yellow indicates the red and green channels are clipped (magenta indicates red and blue, while cyan indicates the problem affects blue and green), and small areas of green show where only that channel is burnt out.

5 As an alternative to the Exposure slider, you can also drag the histogram. Move the cursor over the mid to lighter tones on the histogram and the word Exposure should appear, as well as the slider's value, and the cursor should change into a two-headed arrow. You can now drag the histogram — dragging to the right brightens the image, dragging to the left darkens it.

The Exposure slider is for adjusting the image's brightness and overall appearance. Notice how I've switched to Split Screen to compare my editing work against the image as it was before.

Recovery and the white point

After you have used the Exposure slider to set the image's overall brightness, the next stage is to use the Recovery slider to retrieve any lost highlight detail.

Lightroom's variety of highlight clipping indicators becomes especially valuable here, and I find the Alt/⌥ key to be almost indispensable. As you drag the Recovery slider, holding down Alt/⌥ makes Lightroom show the blown highlights. This takes a lot of guesswork out of the process and you can briskly drag the Recovery slider to the right, check the clipping has gone, and know that the image's brightest tones are mapped to render white.

1 Starting with the Recovery slider set at 0, hold down the Alt/⌥ key and drag the Recovery slider a touch to the right. Lightroom shows unclipped areas as black, completely burnt-out highlights in white, and other combinations of clipped channels using the same colors as when you Alt/⌥-drag the Exposure slider.

3 You can also adjust the Recovery setting by dragging the histogram. As with Exposure, move the cursor over the histogram's right side and wait for the words Highlight Recovery to appear. Now you can now drag the histogram left and right, or leave the cursor hovering and use the keyboard's Up and Down arrows.

2 Keeping the Alt/⌥ key held down, drag the Recovery slider to the right until the clipping is eliminated.

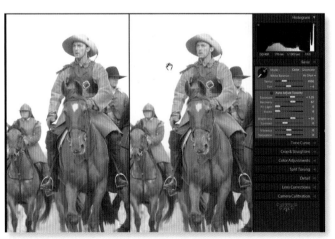

4 When you drag the Recovery slider, you should usually hold down the Alt/⌥ key. But release it occasionally and assess the effect of your work. Here, working in Split Screen mode shows that the Recovery slider has successfully restored detail in the sky.

Before	After
R 100.0 G 100.0 B 100.0 %	R 96.8 G 96.9 B 96.1 %

5 Drag the cursor over the brightest image areas and check the brightness readouts in the Toolbar (T). Notice the position of the cursor in step 4's screenshot. In the Before image, readings from the same area are 100%, indicating they were completely burnt out, but in the After image the brightness readings confirm that there is now usable detail.

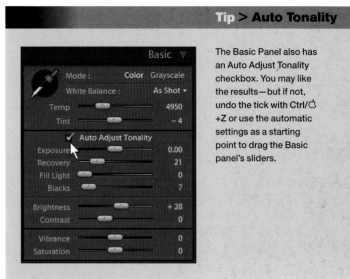

Tip > Auto Tonality

The Basic Panel also has an Auto Adjust Tonality checkbox. You may like the results—but if not, undo the tick with Ctrl/⌘ +Z or use the automatic settings as a starting point to drag the Basic panel's sliders.

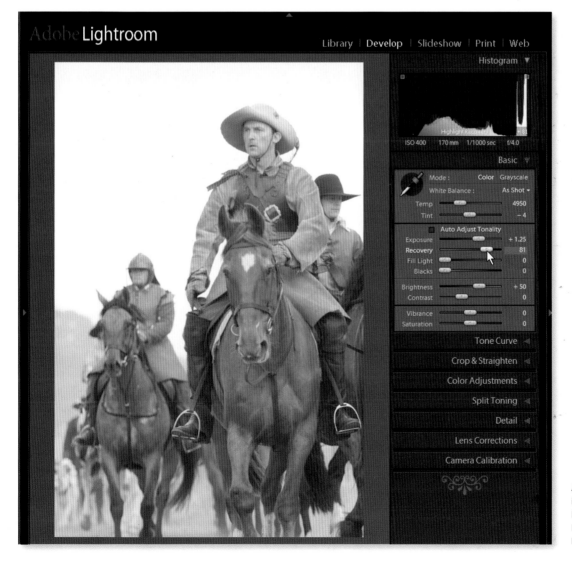

After setting the overall image brightness with the Exposure slider, use the Recovery slider to restore lost highlight detail.

Shadows and the black point

Though not as closely linked as Exposure and Recovery, the Blacks control and the Fill Light slider also work together as a pair. Blacks sets the image's "black point"– the brightness value that Lightroom will output as pure black. It affects the entire image's blackness and shadow tone values. Fill Light, on the other hand, is an "adaptive" adjustment that works only on those parts of the image where there are blocks of shadow, lifting the brightness in those areas and leaving other blacks as a solid anchor for the picture.

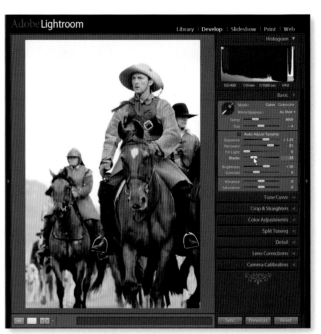

2 Starting with the Blacks slider set to 0, drag the Blacks slider so the original picture's very darkest tones appear black. Again, keep an eye on the Histogram. Here, I dragged the Blacks slider too aggressively and the Histogram shows a spike at its left, indicating I've clipped and blocked up the shadows.

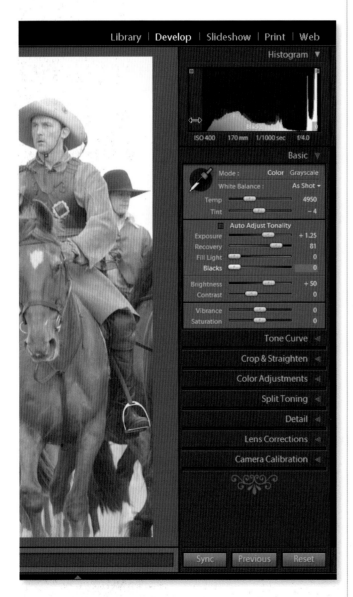

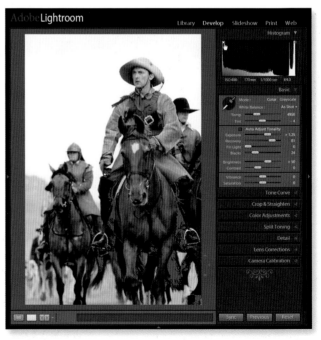

1 Review the image and especially the Histogram before you start to drag the Blacks slider. Here, the Histogram has a gap to its left, indicating that the image's darkest tones aren't black.

3 Make full use of Lightroom's range of clipping indicators. Move the cursor over the Histogram's clipping square and clipped shadows show in bright blue.

4 As with the other Basic panel sliders, you can key in the Blacks value or change it by dragging on the Histogram. Move the cursor over the Histogram's left and wait for the word "Blacks" to appear and for the cursor to become a two-headed arrow. You can then drag the Histogram's shadows left to strengthen them, and right to brighten them.

5 Always hold down the Alt/⌥ key when you drag the Blacks slider. This is often the best way to judge where to set the black point. It's similar to Alt/⌥-dragging the Exposure and Recovery sliders, except holding down Alt/⌥ with Blacks makes unclipped areas appear white and shows clipped areas in color. In this example there are areas of black, indicating blocked shadows with clipping in all channels, and plenty of yellow where only the green and red channels are clipped.

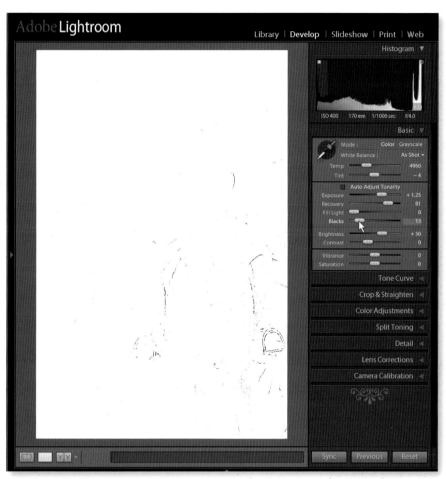

6 Continue Alt/⌥-dragging until you only see a little clipping. A small amount of clipping can anchor the picture on a strong black and can also suppress luminance noise in the shadows.

Tip > Scrubby sliders

The sliders' values are "scrubby." This means the cursor changes appearance as you move it over the value, and you can then drag to change the slider's value.

Fill Light

When a bright background or sky has led the camera to underexpose the subject, the picture may well contain interesting subject detail, but it's indistinguishable in the shadows. You can see detail when you drag Lightroom's Exposure slider to the right, but that often burns out highlights and makes the overall picture unacceptably bright. This is when Fill Light rescues the picture.

Fill Light is the fourth of Lightroom's Basic panel sliders (in order of use). This slider makes "adaptive" adjustments to a photograph, rather like the human eye scans a scene and adapts to its shadows and highlights. Fill Light identifies areas of shadow and lifts their brightness and enhances local contrast, while respecting brighter areas of the picture. Like similar tools, such as Photoshop's Shadow/Highlight adjustment or Nikon Capture's D-Lighting, it's doesn't just rescue underexposed subjects from obscurity—it can also work wonders with well-exposed images too.

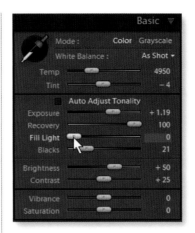

1 Start with Fill Light set to 0 and just drag it to the right.

2 As with the other Basic panel sliders, you can adjust Fill Light by dragging the tones in the Histogram. Move the cursor over the Histogram's mid left, wait for the word "Fill Light" and for the cursor to become a two-headed arrow. Dragging to the left reduces the Fill Light value, while dragging to the right lifts the shadow tones.

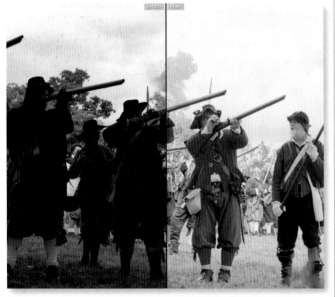

Here the sky was so bright that the subject was underexposed. As this Split Screen view shows, dragging Fill Light to the right did a great job.

3 To see the Fill Light slider's effect on any clipped shadows, move the cursor over the Histogram's clipping indicator and click it.

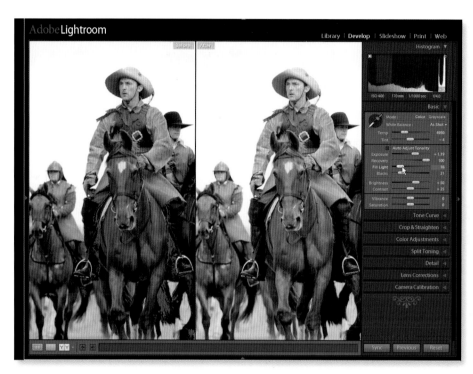

4 Switch to Split Screen view to show the clipping before and after dragging the slider.

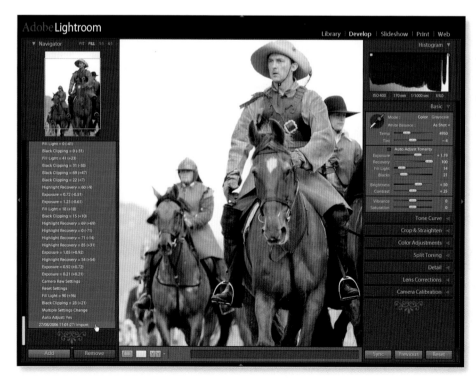

5 At any point you can compare your work with any previous state. Reveal the History Panel (F7) and scroll down. Here I've put the cursor over the image's original import step and this is shown in the Navigator.

Procedure summary

1 Set overall brightness with the Exposure slider

> 2 Restore highlights with the Recovery slider

> 3 Set the black point with the Blacks slider

> 4 If desired, lift the shadows with the Fill Light slider

Color saturation

Photoshop, Adobe Camera Raw and many other programs have always let you quickly enrich an image's colors by increasing the color saturation. Based on the Hue, Saturation, and Brightness color model, the colors are pumped up without affecting their hue or brightness.

While Saturation may be familiar, Vibrance may be a new term unless you have used Pixmantec's RawShooter Pro, whose developers joined the Lightroom team when Adobe acquired the company. Vibrance, like Fill Light (see page 78) is an adaptive adjustment, so it affects specific image areas, unlike Saturation which affects the whole image. The effect is most pronounced on areas of less saturated tone, and least on already saturated areas, so it won't cause a channel to clip. Another key characteristic is that it attempts to detect and respect skin tones. Once you get used to it, you may well start using it all the time.

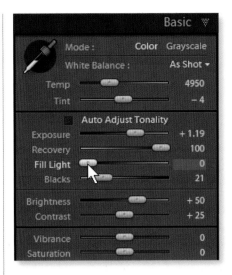

1 The Saturation and Vibrance sliders are at the bottom of the Basic panel.

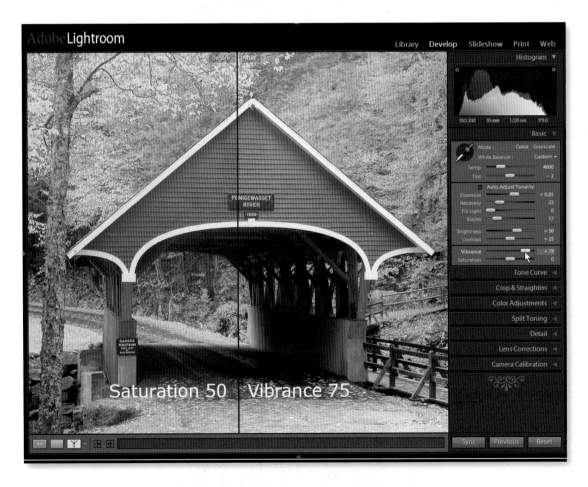

Saturation 50 Vibrance 75

2 To add punch to the whole image, drag the Saturation slider. Sometimes Saturation, which affects all tonal ranges, can be a blunt instrument by comparison with Vibrance, but here a little Saturation works much better and turns an overcast October day into the New England fall.

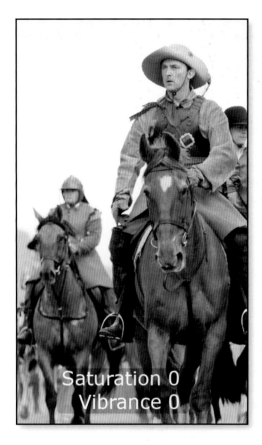

Saturation 0
Vibrance 0

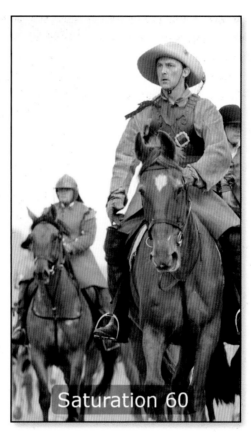

Saturation 60

3 When the picture has more mixed colors, Vibrance has a much more subtle effect. Notice here how the Saturation slider has boosted the colors but makes the leading rider's face almost beetroot-colored and turned his sash a pure red. Vibrance has improved the riding coats and the blue sleeve but has kept the leading rider's skin tones within acceptable limits.

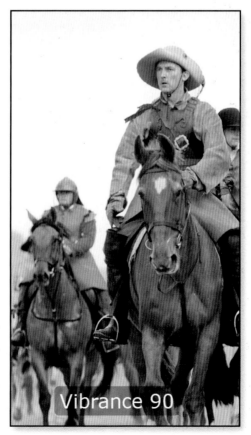

Vibrance 90

Tone Curve > Fine contrast and brightness control

The sliders for White Balance, Exposure, and the other Basic panel tools will usually produce an image fit to print. But a finer degree of contrast and brightness control is also available through Lightroom's Tone Curve. This is designed for those who may have been daunted by Photoshop's Curves adjustments, yet will also satisfy those who regarded Curves as not only the best, but the only way to adjust an image.

The Tones Curve plots the image's "input" tones against how brightly they will be output, and this input-output mapping can be varied by dragging the curve. The input tones are mapped along the chart's horizontal (x) axis, while the output tones are on the vertical (y) axis. Black as 0% is at the bottom left and white or 100% is on the top and right. If you have never used them before, now's the time to have a go.

Here a lighter mid gray was 55% in the original but the curve has been dragged upward and will be output as 65% of white.

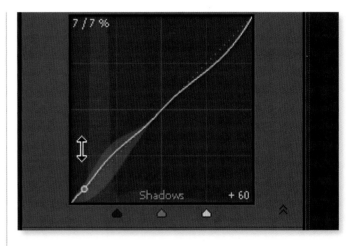

2 Reduce the image's contrast by brightening the darker tones or darkening the lighter tones, or both. So drag the curve's lower left upward, and drag its upper right downward.

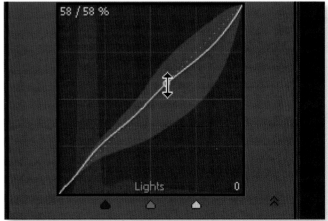

1 To increase the image's contrast, drag downward at the curve's lower left and drag its upper right segment upward. Often called an S curve, this makes sense if you think about how the Curves control works—you're pushing down and darkening the dark tones output, and brightening the lighter tones at the other end of the curve.

3 Tone Curve adjustments can target tonal areas more precisely. Indeed as you move the cursor from left to right over the Tone Curve, you'll notice how the chart is overlaid with the name of the area over which you hover: "Shadows," then "Darks," "Lights," and "Highlights." So, if you want to target the darker midtones, or the Darks, move the cursor to that area of the curve and then start dragging.

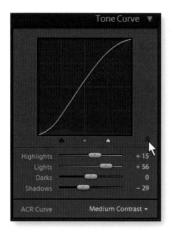

4 As an alternative to dragging the curve, Lightroom has sliders. If they are hidden, click the little chevron to the curve control's right.

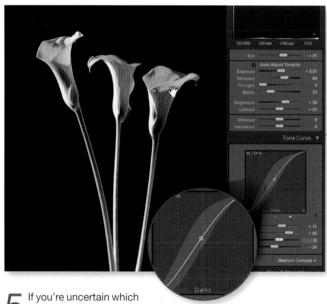

5 If you're uncertain which part of the Tone Curve to drag, move the cursor over the area of the image that you wish to adjust. A circle appears on the curve, showing whether that area is in Shadows, Darks, Lights, or Highlights.

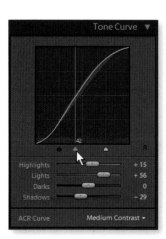

6 You can change the brightness values that Lightroom treats as the Shadows, Darks, Lights, and Highlights by dragging the Split Points, the triangles below the curve.

7 To reverse any Tone Curve work, one option is Undo or Ctrl/⌘+Z. Another is to reset the curve by double-clicking the line, or to right-click the Tone Curve and reset the curve or the Split Points, the triangles below the chart that define the Shadows, Darks, Lights, and Highlights. Also remember that double-clicking any slider resets it to default 0 value.

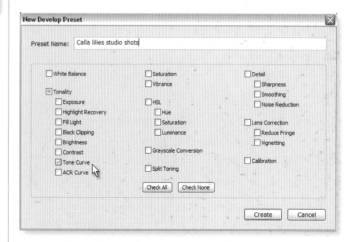

8 When you like a curve's contrast, save it as a Develop Preset. Reveal the Left Panel (F7) and activate the Presets panel. Click the Add button, then Check None in the New Develop Preset dialog box, and then just tick the Curve option.

Black and white

Black-and-white photography wasn't killed off by color film, and digital capture seems to have given it another healthy lease of life. Some digital cameras let you save black-and-white JPEGs, even filtering the color channels for more creative control, while raw shooters can now decide at their leisure if the picture works best in black and white or color, or if they want to output it in both formats.

At its simplest, Lightroom can convert an image to black and white with a single click, and the results may be sufficiently good for proofing. But black-and-white photography is about more than simply turning off the colors and so Develop's Grayscale Mixer panel lets you set how the original's individual colors are rendered as grayscale values. This gives you some control over where the dark and light tonal areas are positioned within the frame, so you can rebalance the image, as well as vary the picture's interpretation of its subject.

Two conversion methods in Library

In Library's Quick Develop panel, select a Preset that makes the picture black and white.

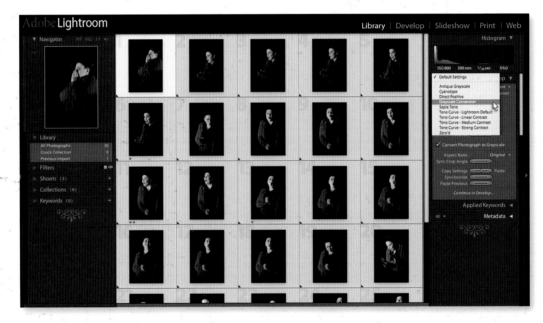

Alternatively, in Library, select one or more images and tick Convert Photograph to Grayscale in the Quick Develop panel. Here, Lightroom is halfway through making all these pictures black and white.

Develop > Fine control

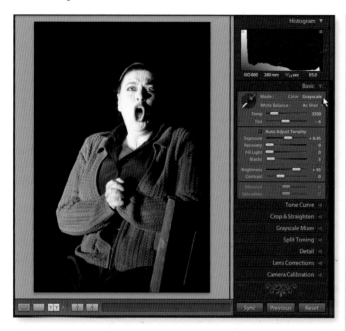

4 Now drag the Grayscale Mixer sliders to lighten or darken how each color is converted to black and white. Here I simply darkened yellow and red, which improved the skin tones, but we'll see more creative uses of these sliders in the next few pages.

1 For finer control of the black-and-white rendition, select an image and switch to Develop. Make your adjustments in Basic (F8) and press the Grayscale button.

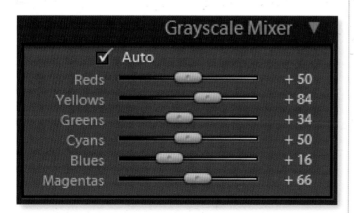

2 Once you have switched the image to Grayscale mode, the Grayscale Mixer appears in Develop's right panel (F8). Initially this is set to Auto, but you can now drag these sliders. If you drag any slider to the left, you darken how that color appears in black and white, while dragging to the right lightens it.

3 At this point I like to switch to Split Screen mode, because once you've switched an image to Grayscale it's easy to forget what the original colors were.

Black and white > The Grayscale Mixer method

If you're short of time, we've seen that Lightroom's default black-and-white conversion is very quick indeed—select the pictures in Library and tick the Grayscale box in Quick Develop. But it really doesn't take that much longer to fine-tune a single image and then copy your work to the rest of the shoot. And as we have just seen, you can use Lightroom's Grayscale Mixer to balance a picture's tonal composition and vary its interpretation of the subject. Here we'll examine the Grayscale Mixer in more detail, to show how you can easily make the final black-and-white image so much more expressive, and in so little time.

1 In Develop's Basic panel, drag the various sliders to fine-tune the tonality. Click the Grayscale button, and review the results. Notice here how Lightroom's default conversion has maintained the skin tone but has made the man's shirt very bright—drawing the eye away from the picture's very dark subject.

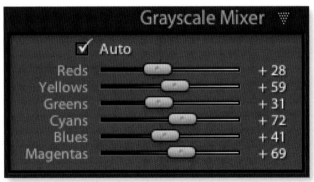

2 Using Develop's Grayscale Mixer, it's easy to rebalance this picture by dragging the color sliders. Drag a slider left to darken the image areas that were originally that color.

Apart from the thoughtful expression, notice this man's well-tanned face and his shirt's pale blue color. You can use these colored areas to balance and control the black-and-white image's tonality.

3 Once you've made the picture black and white, it's surprisingly easy to forget the subject's original colors, so switch to Split Screen with its Before and After views. I want to darken the shirt, and Split Screen reminds me it's blue, so I drag the Blues slider first.

4 The same idea applies to skin tones, and this is where interpretation should creep into the thought process. Harsher skin tones often work best with men, and Caucasian faces have plenty of reds, so dragging Grayscale Mixer's red slider to the left will darken the skin. In this case, if you had never seen the original, you'd be in little doubt that he was very well-tanned.

5 Equally, dragging the red slider to the right will lighten skin tones, which is (without wishing to generalize) frequently useful on pictures of women and children. Dragging the red and magenta sliders to the right has lightened the man's skin tone and made his skin tone softer. Again, if the viewer had never seen the original, the picture would be believable as a portrait of a lightly tanned man.

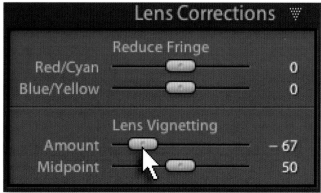

6 Here I chose to darken the corners by dragging the Lens Correction panel's Vignetting slider to the left. Like darkening the shirt and lightening the skin tones, this little finishing touch draws attention toward the subject's face.

Lightroom's Grayscale Mixer lets you fine-tune the black-and-white conversion, change the image's tonal balance, and gives you precise control over how the viewer interprets the subject.

Black and white > The Saturation and Luminance method

Develop gives you more than one way to produce black-and-white images. As well as the Grayscale Mixer method, an alternative is to drag the Color Adjustments panel's Saturation and Luminance sliders. Dragging the Saturation slider to 0% results in a desaturated color,

while the Luminance slider controls how brightly that color is rendered in black and white. The principle is similar to the Grayscale Mixer method, but Saturation and Luminance can often produce much better results.

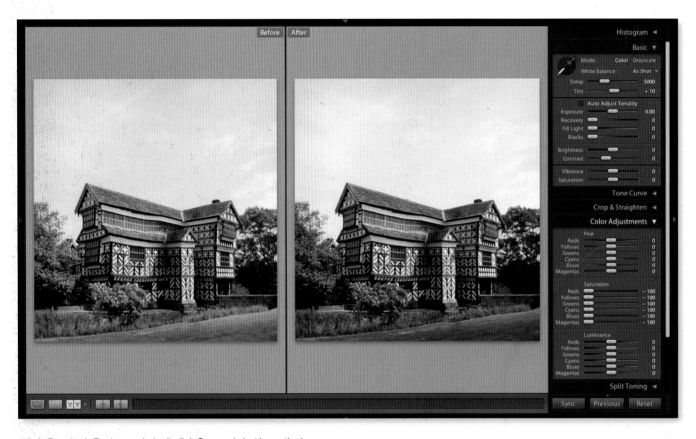

1 In Develop's Basic panel, don't click Grayscale but leave the image in Color mode, and in the Color Adjustments panel, drag all the Saturation sliders to the left. Initially this can produce a somewhat bleached result that is as bland as the Grayscale button's default output.

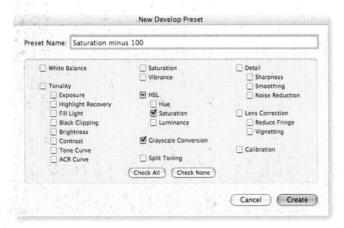

2 It's a chore always dragging the Color Adjustments panel's seven sliders to the left, so save a Preset. In the Left Panel, click Add and leave only the Saturation and Grayscale boxes ticked.

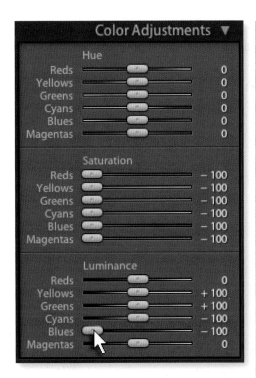

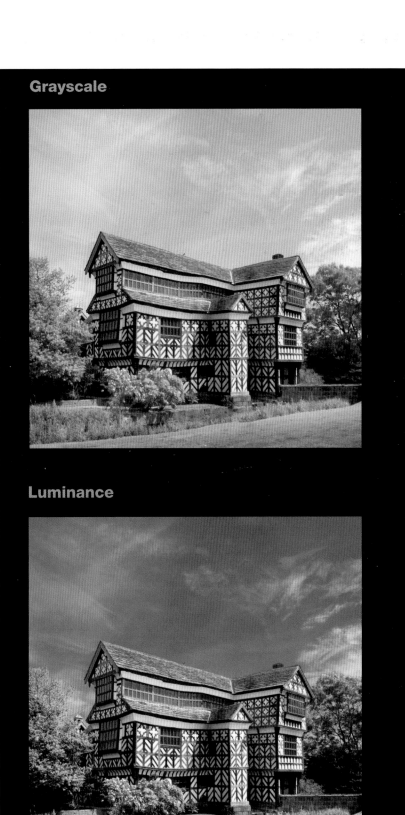

Grayscale

3 Now drag the Color Adjustments panel's Luminance sliders and watch the resulting output. It's the same principle as with the Grayscale Mixer—dragging a color's slider to the left will darken how it appears in black and white, while dragging to the right has the opposite effect.

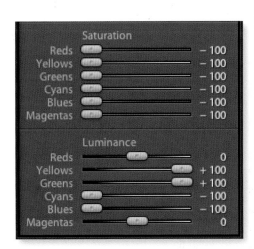

Luminance

4 Manipulate the black-and-white rendition by dragging the other Luminance sliders to suit the image. Here I beefed up the sky by pulling the blue and cyan sliders hard to the left, and lightened the trees and grass by dragging the green and yellow sliders to the right.

The Saturation and Luminance method often produces much better results than the Grayscale Mixer method. Here the sky is stronger and the grass and trees are brighter.

Black and white > Timesavers

Lightroom is all about working with large numbers of photographs. So while the last few pages have been about trying to squeeze that bit more quality and expression out of a black-and-white picture, let's not disregard the efficiency of the workflow.

1 If you have a Develop Preset, there's no more need to drag the Color Adjustments panel's Saturation sliders when you work on another picture. Click the Preset in the Left Panel (F7)—here I am applying the "Saturation minus 100" Preset which I originally created when working on the timber frame building (see page 88).

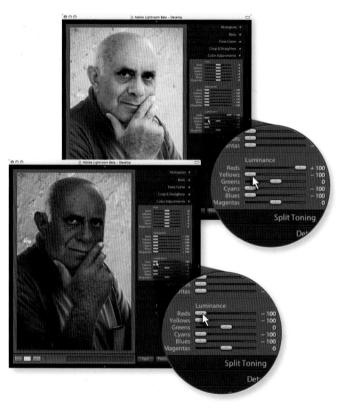

2 With the time that the Preset saved you, fine-tune the black-and-white rendition by dragging the Color Adjustments panel's Luminance sliders. The picture's interpretation can vary wildly, so experiment. Notice the effect of dragging the red slider on the skin tones in this portrait.

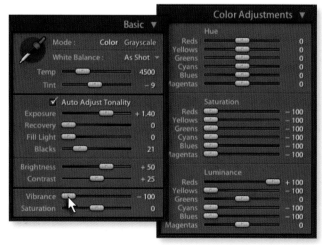

3 The Saturation and Luminance method means Develop's other color controls, which are disabled in Grayscale mode, remain available. Here I dragged the Vibrance slider to the left and strengthened the color of the shirt.

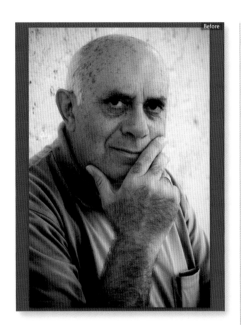

Before

5 When you've finished work on one image, reveal the Filmstrip (F6) and select the other images in the sequence. Here the current image's background is brighter than the others.

6 Click Sync, and carefully select the adjustments you want to copy to the other pictures. I prefer to begin by clicking None, and then tick just the boxes I need.

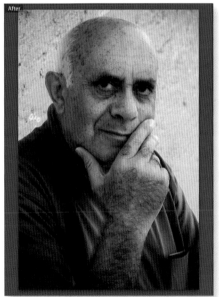

After

4 The Saturation and Luminance method has another advantage— thanks to the Color Adjustments panel's underlying calculation, it can't produce clipping in any color. Compare the results of the Saturation & Luminance method (After) and the Grayscale method (Before).

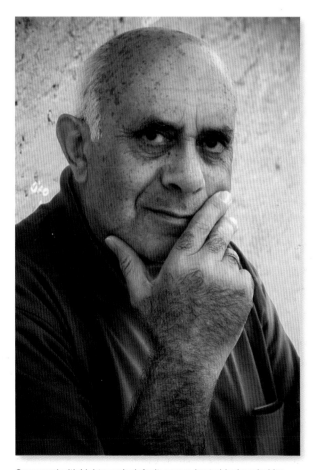

Compared with Lightroom's default conversion to black and white, the final result subdues the tonality of irrelevant image areas like the shirt and draws attention to the subject's pensive expression.

Single and split tones

Digital imaging has also given toning a welcome boost—experimenting with tones on screen is far more consistent and predictable than traditional methods, and certainly offers a much friendlier environment than subjecting your prints to often poisonous chemicals. I've even heard of photographers who adopt split toning as a workaround for the casts their inkjet printers produce instead of black and white. In more deliberate circumstances, a well-chosen tone often gives a picture or series of pictures a completely fresh interpretation.

Lightroom's Develop module has a Split Toning panel in the Right panel (F8). This allows you to target the highlights and shadow tones and change their hue and saturation. First of all, make sure you have a pleasing black-and-white rendition, and then add a single or split tone as a quick and tasteful finishing touch.

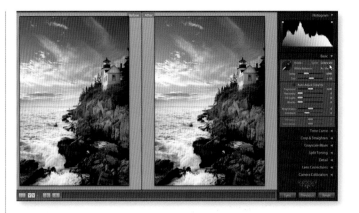

1 In Develop, convert the picture to black and white. My starting point is a shot of Maine's Bass Harbor lighthouse, a TIFF file that I saved in Photoshop and imported into Lightroom. As usual, the first steps are to click Grayscale in the Basic panel and display Split Screen's Before and After view (see pages 86-87).

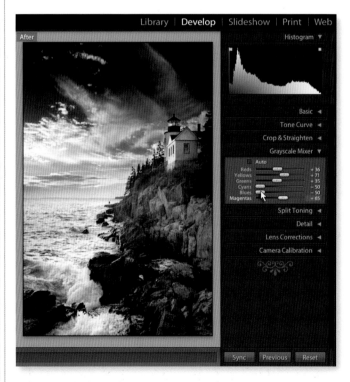

2 Fine-tune the monochrome rendition in Grayscale Mixer. I wanted to strengthen the sky in this shot, so I dragged the Blue and Cyan sliders to the left, darkening the blue and cyan parts of the picture.

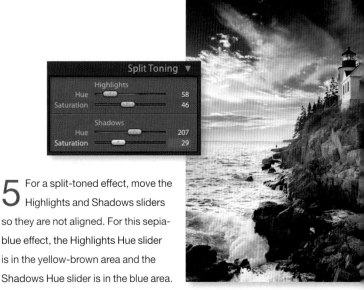

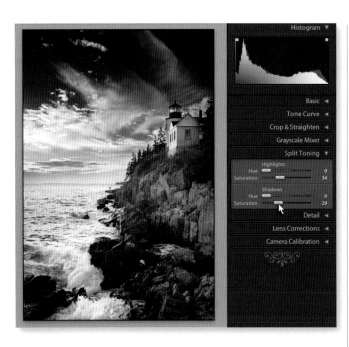

3 Go to Split Toning and drag both saturation sliders to the right. Any values will do—but if you leave saturation at 0% you won't be able to see the effect when you drag the Hue sliders.

5 For a split-toned effect, move the Highlights and Shadows sliders so they are not aligned. For this sepia-blue effect, the Highlights Hue slider is in the yellow-brown area and the Shadows Hue slider is in the blue area.

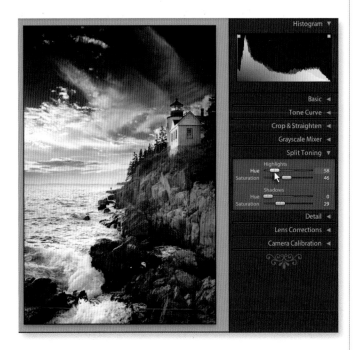

4 Drag the Hue sliders to the right. It doesn't matter if you drag the Highlights or the Shadows slider first—just move them until you are happy with the result.

6 For a single tone, drag the Highlights and Shadows sliders so they are in the same area of their respective color bars. For my 19th century selenium-toned "Brady preset" (see p110 for more on presets) both Hue sliders were left at 0 in the red zone, while the restrained tone resulted from leaving the Saturation sliders at 25%.

7 If you think you might want to repeat the toning, add a Preset. Reveal the Left Panel (F7) and click Add in the Presets panel. Tick just the key characteristics you anticipate reusing—in this case the split toning, not the Grayscale mixer settings that were specific to this image.

Color adjustments

It has now become almost a routine task to adjust the colors of your images in post processing. In skilled hands there's not much Photoshop can't do, since the color of every single pixel is individually adjustable.

Lightroom doesn't have such a scope, but with a wide color space, and being based on the Hue, Saturation, Luminance model of defining color, the sliders in Develop's HSL panel can make dramatic changes to an picture's color balance. At first, the best way to work with the HSL panel may not be obvious. But instead of using the sliders, I'd encourage you to use the cursor. Those who use a graphics tablet will find the technique comes quickly, but mouse users will also love to adjust colors simply by stroking the image.

1 Simply moving the cursor over an HSL panel slider will make it active, and lets you use your keyboard's Up and Down arrow keys to adjust its value.

2 As the cursor moves over the slider's value it becomes a "scrubby slider" and can be dragged to change the value.

3 Double-click the label to reset a slider's value.

4 Pull down the HSL panel's switch to turn off its effects.

5 All of these were relatively unexciting ways to work, and mean you're continually having to alternate between thinking about the picture and making sure you grab the correct slider button. Instead, click the small button to the panel's top left. I'd like to tone down the boy's shirt in my image, so I've activated Luminosity and clicked the button.

6 This changes the cursor into a crosshair with a small vertical scrollbar, and makes it act like a painting tool. As you move it over the image, it highlights the slider panel whose color is closest to that part of the picture—in this case, Red. The cursor can now be used to control the sliders while you keep your eyes on the picture.

8 To decrease a slider's value, drag downward in one big movement or a few little ones, almost like paint strokes. Bigger strokes move the slider farther. But try to keep each stroke within blocks of similar color so that you don't, for example, drag over the green background when you only want to adjust the reds.

Using the HSL panel, the cursor becomes a brush whose strokes control the panel's sliders. In this way you can change the slider values while keeping your eyes firmly on the picture.

7 To increase a slider's value, drag upward in a part of the picture where there is a lot of that color. Dragging upward across the boy's shirt has increased the red and orange sliders, and, since the HSL panel is on Luminance, increasing those sliders makes the shirt brighter.

Split Screen

Lightroom makes it easy to adjust the Highlights, Recovery, Fill Light, and Blacks sliders and then charge quickly on to printing the image. But if you're trying to take your work up to the next level, we've already seen how it takes no time at all to hold down the Alt/⌥ key while dragging a slider or glancing at the Histogram. These aren't the only Develop tools that you can use in conjunction with the various Right Panel sliders. I particularly like to use Split Screen and routinely use it when clearing dust spots. The more visual clues you can routinely force yourself to see, the more consistently you can squeeze that crucial extra quality out of your pictures, and the less you'll be forced to compromise under pressure of time.

1 Make sure you can see Develop's toolbar. If it goes missing, hit the letter T on your keyboard—this toggles the toolbar's visibility.

2 Switch to Lights Dim mode whenever you find Lightroom's panels too distracting. It's usually faster to use the keyboard shortcut—the letter L—but you can also go to *Window > Lights Out > Lights Dim*. To restore the panels' normal appearance, press L a couple of times more. Here I've also hit F7 to hide the Left Panel.

3 Displaying your edited picture side by side with the original can be a highly effective way to judge your work. Click on the Split Screen button, or press the Y key—pressing it once goes into Split Screen, and a second time takes you back to the normal view.

4 For landscape-format images, you can also use Alt/⌥+Y instead of Y to split the screen horizontally.

5 Split Screen is especially informative when you use it in combination with the Histogram's clipping indicator. As you drag the Develop panel's Exposure and Recovery sliders, for instance, you can watch their effect on the image and compare the clipping before and after any editing.

7 Split Screen's Before view usually shows how the picture looked when you entered Develop, but you may like the picture's appearance after some editing and want to use its current state as a benchmark while you make more adjustments. Click the toolbar's Copy Left button.

6 Zoom in and out while in Split Screen mode. Ctrl/⌘+⊞ zooms in, while Ctrl/⌘+⊟ zooms out again. Here I've zoomed in to deal with a sensor dust spot in the river.

Dust spots

Camera makers have come up with a variety of ways to automate the removal of the sensor dust spots that bedevil digital **SLRs**. These range from vibrating the sensor through to software solutions that are often based on shooting reference photos. But spots can move or change character with different apertures, and new ones appear from nowhere, so despite all these efforts you often end up manually cloning them away in Photoshop, one image at a time.

Lightroom's Healing tool both clones and heals, blending the repaired area into its neighborhood. As a metadata-driven editor, it needs to define spots' locations and shapes and how they are to be replaced, and this brings **Lightroom** close to editing individual pixels like a bitmap editor. Every so often, you'll get a blemish so awkward that you'll still have to resort to Photoshop, but you'll be glad to know that Lightroom's dust-busting method is fast and intuitive for over 90% of dust spots.

This crisp blue sky revealed a multitude of sensor dust spots. Here the aperture setting was f6.3 so they weren't sharply defined.

2 Now activate Lightroom's Healing tool. You can click the toolbar (T) icon or use the keyboard shortcut O which toggles the tool on and off.

1 You can often identify dust spots when the image is full screen, but it's almost always best to zoom right in to clean them up. Activate the Hand tool (H) and click the first spot.

3 Drag the cursor over the dust spot and a small repair ring will appear.

4 As you release the cursor, the repair ring around the dust spot turns red, indicating it is active, and it is linked to a second green ring which shows the image area Lightroom sampled to heal the spot. With evenly toned features, like my sky, the healing can be right first time and you can move on to the next one.

6 To change the area Lightroom uses for the repair sample, you can drag the sample ring around your picture. If a repair ring is white, clicking it will activate it, turn the ring red, and make the green sample ring appear. Then just drag the green ring to somewhere more suitable as a sample.

5 Where the spot's surroundings are more varied, you need to be more careful because the green ring's sample can be unsuitable. Here Lightroom has drawn its sample from St Peter's key.

7 There's rarely just one dust spot on a picture, so make good use of the keyboard shortcut Ctrl/⌘+⊟ to zoom out, find the next one, and then zoom back in again with Ctrl/⌘+⊞. The Healing tool remains active, showing all the spots you've had to repair, so switch off the Healing tool by hitting the O key, drag the image around, and then toggle the tool back on again.

Tip > Deleting repair rings

To delete a repair ring, click to activate it and then hit the Delete key.

Dealing with noise

Higher ISO and underexposed images contain more noise, random tonal variations that appear particularly in the shadow tones but sometimes extend up into the midtones. Photographers' reactions differ. For some, digital noise is merely incidental–not as attractive as fast film's grain, perhaps, but just what you expect of images shot in lower light. Others use specialized noise reduction tools to achieve higher quality output or offer

a smoother workflow than Photoshop's noise reduction techniques. Lightroom's noise reduction feature will be familiar if you have used Adobe Camera Raw, and it will be all most people will need, most of the time. But developers have yet to take advantage of Lightroom's modular structure and offer specialized noise reduction modules for it, so more demanding noise reduction requirements will require other workflows.

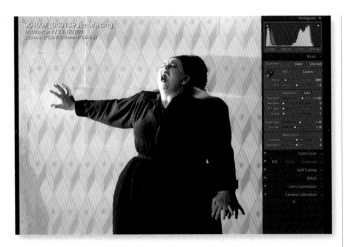

1 In challenging lighting conditions, you may vary the camera's ISO sensitivity setting over the course of a shoot—this opera shoot was mostly at the top end of an ISO range from 400 to 1200. Since luminosity noise relates closely to the sensitivity setting, it can be helpful to give yourself an extra indication that you are dealing with a high ISO image and remind you to focus some time on noise reduction. In Develop, press I to display the information overlay.

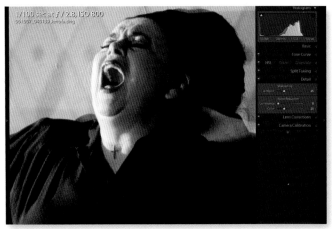

3 Do your other Develop work first, and then zoom in to 100% to deal with noise. Use Ctrl/⌘+⊕, or better still, click an important shadow area of the image, because that's where noise will be more prominent. Then display the Noise Reduction controls in the Right Panel (F8)—they're under Detail.

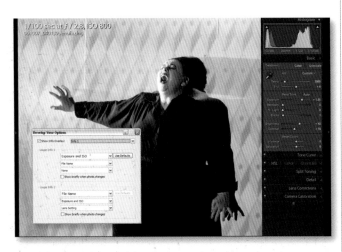

2 If the ISO isn't prominent enough, press Ctrl/⌘+J and alter the fields displayed in the overlay.

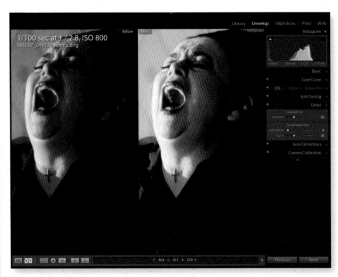

4 Before you drag a slider, switch to Split Screen by pressing the Y key to split the display vertically, or Alt/⌥+Y to split it horizontally.

5 Also click the left arrow toolbar button to make the Before panel show the image's state before any noise reduction.

6 Now drag the Noise Reduction slider and watch the results carefully, comparing them against the Before panel. Move around the image, checking important areas. As you increase the slider, you lose some detail—it's very much a matter of judgement.

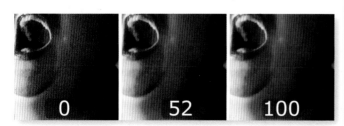

It's worth making detailed comparisons to assess the effects of noise reduction.

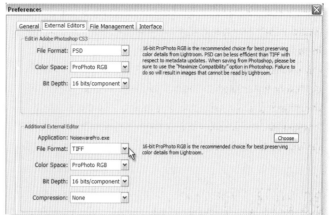

7 If you do a lot of high ISO work, you may already use a specialized noise reduction program tool like Noise Ninja or NoiseWare. If so, set it up in Lightroom's Preferences as an external editor.

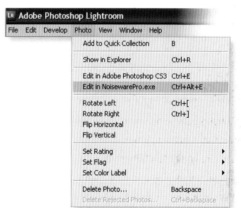

8 Activate your external editor when you've finished your Develop work.

Photographers are as divided about digital noise as they were about film grain—some love it, some will do anything to suppress it.

Chromatic aberration

The third of the "zoomed in" tasks (see page 66), is to check for chromatic aberration. This magenta or occasionally cyan fringing sometimes appears along high-contrast edges. It can be the result of poorer quality lenses or of certain combinations of lens and digital camera, and it's not unusual to notice it most with wide-angle shots when the aperture is wide open.

Develop's Lens Correction panel has a Reduce Fringe tool which consists of a pair of sliders that counter chromatic aberration. These Red/Cyan or Blue/Yellow sliders work by detecting edges and locally adjusting the red or blue channels. The key to their effective use is to zoom right in, work with the Split Screen view, and hold down the Alt/⌥ key as you drag the sliders.

1 When you are trying to resolve chromatic aberration problems, always zoom right in by using the keyboard shortcut Ctrl/⌘+⊕ or by clicking the Navigator. At 1:1 you might detect a problem, but 4:1 is generally much better because you can see both the fringing problem and judge the subtle effect of your corrections.

3 Switch to Split Screen mode. The Reduce Fringe sliders have very subtle effects indeed and it's important to check you are improving the fringing, and not making it worse, as can easily happen.

2 Chromatic aberration is most apparent at high-contrast edges, so move around the image by dragging the image itself. Alternatively, drag the Navigator. This has the advantage that you can quickly target areas where you expect fringing problems, and here I thought the highest risk would be the cast-iron roof. After you've found a problem area, hide the Navigator panel with the F7 key.

4 Also turn off any sharpening (see page 104) in the Detail panel. This lets you see the pixels without adjustment. Of course, if you do this, you have to remember to restore the sharpening later.

5 Drag the Reduce Fringe sliders—Red/Cyan if the chromatic aberration is magenta, and Blue/Yellow if it's blue. Watch closely their effect on the fringing—here it is becoming much too pronounced.

7 Save a develop preset if you often repeat the same correction for a particular combination of lens and camera. Reveal the Presets panel (F7) and click the Add button. Click Check None, then tick the Reduce Fringe checkbox by itself. Notice too that I've named my Preset "Lens correction—17-35mm wideangle magenta fringing" because this helps me quickly locate all the other presets that relate to the Lens Correction panel.

6 Hold down the Alt/⌥ key when you drag either slider. This hides the channel that isn't affected by the adjustment—in this case the Blue channel—and makes it easier to make the appropriate correction. Repeat the process with each slider just in case the fringing is a combination of magenta and cyan.

8 That said, rather than use a preset, I generally prefer to resolve chromatic aberration on individuall frames. Reveal the Filmstrip (F6) and check you have selected the other pictures with the same characteristics as the one you've just corrected. Then click the Sync button to apply just the fringing adjustments—again click the Check None button and tick just the Reduce Fringe check box.

Tip > Lens correction tools

Specialized lens correction tools such as DxO Optics Pro can make very sophisticated adjustments for distortions and output the result as a DNG file as well as in TIFF or JPEG format. Such tools may be used to prepare images before you import them into Lightroom or as external editors when you've finished your Lightroom editing.

Sharpening

At some point before it is printed, a digital image often requires sharpening—an increase of contrast along the edges of neighboring light and dark areas that makes the final result look sharper.

A popular approach is to break this down into three phases. At the start of editing, a little "capture sharpening" can counter digital images' inherent softness. This applies more to RAW captures than to JPEGs (which are generally sharpened in camera). A second stage, "creative sharpening" is used only on selected areas, for instance around eyes, and its application is always a subjective decision—some pictures simply don't need it. Finally, "output sharpening" optimizes the picture for its final output size and the resolution of the chosen output medium, the inkjet print or the web graphic for instance. It's not important if that output sharpening looks brutal on the editing screen because your monitor is not the final output medium. In all cases the aim is perceptible sharpening but without causing a halo around details or increasing artefacts or exaggerating digital noise.

Lightroom's luminosity-based sharpening is found in two places: Develop lets you apply capture sharpening, and Print applies a varying amount of sharpening upon output. Creative sharpening, however, is always applied selectively, so it is something you would need to accomplish in Photoshop.

1 Complete your Develop work and then click a key area of the image and zoom in to 100%. Unless you're zoomed right in, you won't see the results of sharpening. Notice too that I've gone into Split Screen mode.

2 Lightroom's Sharpening control is under Detail, in Develop's Right Panel (F8).

3 Drag the slider and consider its effect on the picture. This is a matter of personal taste and judgement.

5 There's a choice of Low, Medium, or High. Again, this is where your personal style or the picture's own qualities are critically important, not an area for hard-and-fast rules. Review the print carefully.

4 Output sharpening is in the Print module, under Print Job.

Lightroom has a capture sharpening control in Develop, and output sharpening in Print.

From one to many

When you need to print just a couple of pictures, you can afford to work on one in Photoshop and repeat the editing steps on the other. If there are more than a few pictures to process, Photoshop actions can make the work reasonably efficient, and Bridge's Image Processor script lets you leave the computer unattended to finish the job. But as the numbers grow this can easily become cumbersome. Lightroom works on the assumption that you have far too many pictures to process one after the other. You need to select a sequence of pictures, develop one, apply the changes to the rest, perhaps vary them slightly, then move on to the next group. The earlier you can get into this mentality, the sooner the program starts saving you significant amounts of time. That's not just in terms of crude throughput—it's just as important that a shoot should have a consistent appearance and quality.

1 As a starting point, fine-tune a picture in Develop. Here I created a cold split-toned effect that I planned to apply to a series of abstracts of New England leaves.

Using presets

2 As I hope I've made clear by now, presets are great time savers, and are a quick way to apply your image's treatment to lots of other pictures. You can apply them in other Lightroom databases and share them with colleagues. Save presets by clicking the + sign in Develop's left panel (F7).

3 Check just the boxes that are strictly relevant to the effect.

4 In Develop, apply your preset to another picture by clicking its name in the Presets panel (F7).

5 In Library, select one or more thumbnails, and choose the Develop Preset from the Presets drop-down menu in Quick Develop. This is the fastest way to apply the Develop Preset to large numbers of pictures.

6 Remember you can also apply a Develop Preset in *File > Import Photos*. This can be useful if you like all your pictures to have slightly more saturated "Velvia" colors. Create a develop preset with saturated greens and reds, and apply it to all pictures upon import.

In Develop

7 You don't need to save a Develop Preset. After fine-tuning one picture in Develop, use the keyboard's right arrow to move to the next picture, and use Ctrl/⌘ +Alt/⌥+V or the menu *Develop > Paste Settings from Previous*. Lightroom takes the Develop settings that it applied most recently, and applies them to the current image.

8 Alternatively, move on to the next picture and click the Previous button at the bottom of Develop's right panel (F8).

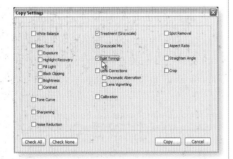

9 An alternative is *Develop > Copy Settings* or Ctrl/⌘+Shift+C. This allows you to specify exactly which settings you wish to apply to other pictures. It would be useful if you wanted to apply my split tone to other Images, but dldn't want to change settings such as Exposure.

10 Then move through Develop with the keyboard's arrows and press *Develop > Paste Settings* or Ctrl/⌘+Shift+V.

Using the Filmstrip in Develop

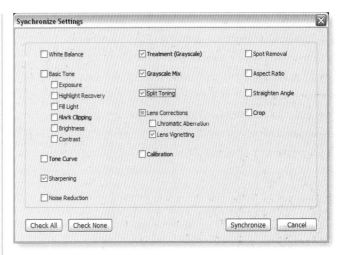

11 Another approach is to reveal the Filmstrip (F6). Keep the current image selected, then hold Ctrl/⌘ or Shift and click other thumbnails.

12 Click the Sync button at the bottom of Develop's right panel, or choose *Develop > Sync Settings* or Ctrl/⌘+Y. In the Synchronize Settings dialog box, tick just those settings that are relevant.

In Library's Grid

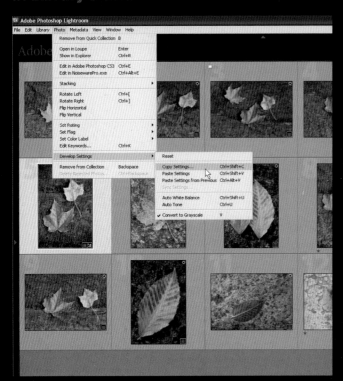

13 In Library's Grid view (G), select the photograph you fine-tuned, and then choose *Photo > Develop Settings > Copy Settings* or Ctrl/⌘+Shift+C.

14 Just like in Develop, you can then apply those settings to other pictures using *Photo > Develop Settings > Paste Settings* or Ctrl/⌘+Shift+V.

Alternative versions

Lightroom's Develop module helps you fine-tune individual pictures very precisely. But you wouldn't be getting the most out of the program if you then repeated the same steps on the next image. Lightroom really is at its best when you're working with many images and can save you lots of valuable time by transferring the detailed work from one shot and applying it to other shots, even to the entire shoot. One of the most efficient ways to do this is to create a Preset in the Develop module.

There are other good reasons for creating a Develop Preset. You may need the same adjustments for future shoots–do your fine-tuning work once, save the Preset, apply it to the next job, and the one after that. Or you may need to prepare a Slideshow so the client can choose from a range of sepia-blue split-toned effects and see the results applied to the whole shoot. In the example here I originally supplied color prints but then decided this American Civil War reenactment merited a more authentic treatment. No doubt you can think of plenty of other applications.

2 Once your photograph is ready, reveal the Left Panel (F7) and click the + (plus) symbol on the Presets panel.

3 Click Check None in the New Develop Preset dialog box. I think this is a good habit because later it will mean you won't accidentally overwrite any existing adjustments—to exposure, for example.

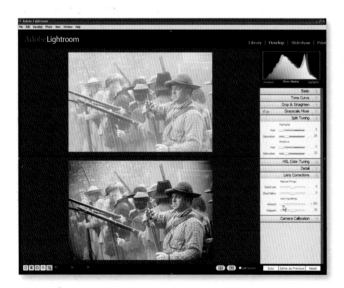

1 Start by fine-tuning one picture until it's just right. Here, Grayscale and Split Toning mimicked the color of mid 19th century photographs. Notice too how I increased Vignetting by dragging the slider to the far left. That's not something I often do, but I felt it suited this series of pictures. Modern lenses can be too perfect!

4 Tick just the adjustments you need. Here I chose Grayscale Conversion, Split Toning, and Vignetting.

5 Name your Presets systematically. Over time you will create many Presets and a naming convention helps you manage such a long list. You can double-click Presets to change their names.

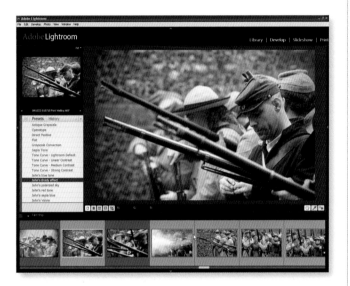

6 To apply your Preset to other images while staying in Develop, click one picture at a time in the Filmstrip (F6), and then click the Preset in the Left Panel (F7). Notice that although I've selected a few items in the Filmstrip, the Preset only applies to the "most selected" item.

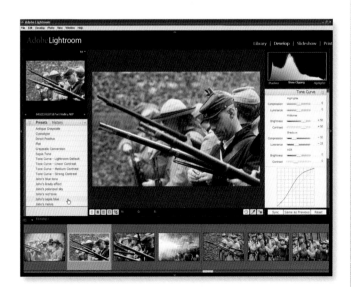

7 You can easily review the effects of your Presets by dragging the mouse over their names in Develop's Presets panel.

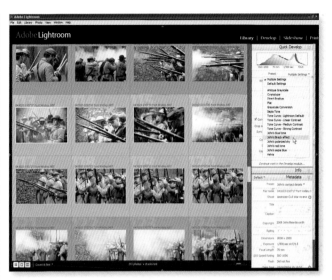

8 To apply your Preset to many pictures at once, go to Library, and select the images. Remember Shift-clicking selects a sequence of frames, while Ctrl/⌘-clicking lets you select or deselect individual pictures that aren't adjacent. Then in Library's Right Panel (F8), go to Quick Develop and choose your Preset from the list.

9 To change a Preset, apply it to one image and then fine-tune the image in Develop. When you're finished, right-click your Preset in the Presets panel and choose Update with Current Settings. Here I've removed the Vignetting.

Alternative versions > Large batches

Digital photography makes it easy to produce alternative versions of a picture–a black-and-white treatment, for instance, or alternative crops. With Photoshop that means saving a number of different files, reserving space on your hard drive for them, and spending time and effort keeping track of all the alternatives. The problem becomes much

more onerous when you supply alternative versions of entire shoots. Lightroom assumes that this is how you need to work and its virtual copies feature is designed to let you produce as many alternatives as you need without all the burdensome overheads.

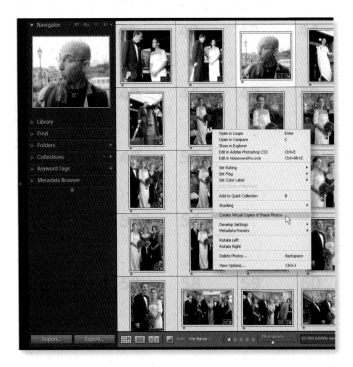

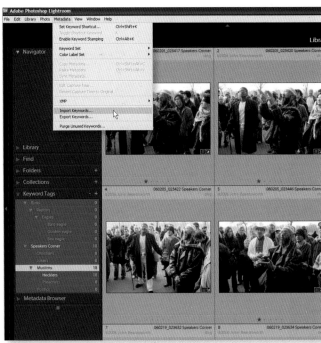

1 In Library's Grid view (G), select the pictures of which you want to make alternatives.
Right-click the thumbnails, and choose "Create a virtual copy of these photos."

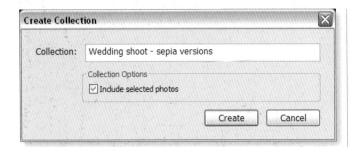

2 Lightroom adds another instance of each thumbnail. Importantly, these virtual copies are initially selected, so immediately save the virtual copies as a Collection. Press Ctrl/⌘+N and make sure "Include selected photos" is ticked.

3 It's easy to find the virtual copies later by clicking the Collection's name in the Collections Panel (F7).

4 The virtual copies are also identified by a little turning page symbol at the thumbnails' bottom left. If this symbol isn't visible, cycle the View Style (J).

6 Now you can edit the virtual copies in Quick Develop or Develop. And there's no need to stop with just one virtual copy—in this example I have made six treatments of the same image.

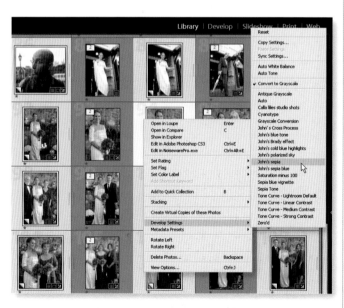

5 If you plan to apply a Develop preset, leave the thumbnails selected, right-click them, and choose a Develop preset. Here I've selected hundreds of pictures from a wedding and you can easily imagine how efficient this process can be—right-click to create the virtual copies, Ctrl/⌘+N to save the Collection, right-click to apply a Develop Preset.

Lightroom's virtual copies mean you can supply endless alternative treatments of entire shoots without needing to store individual working files.

History and Snapshots

After you edit a picture in Photoshop, save the file and close it, you can't generally undo the work you've done. Hopefully, you'll have used adjustment layers, kept pixel edits on layers, and if you're a very astute user you may even have kept the original image as a smart object, whose raw conversion can be adjusted. But in general, pixel edits are permanent.

Lightroom works on different principles: instead of storing pixels, only editing instructions are saved in its database and they can be replayed each time you want to output the image. They can be reversed, too.

2 The best way to backtrack through the work you've done on an individual picture is to use its History. Go to Develop's History panel (F7) and move the cursor over previous editing steps. As the cursor moves over a step, the Navigator shows the picture's appearance at that point. You can click the step, and the picture is restored to that editing state—here I could restore a color treatment.

1 *Edit > Undo* or Ctrl/⌘+Z works in Lightroom just as in most other Windows and Mac programs. Undo is not particularly efficient and can cause confusion when you're working with a few images at once—you can easily undo editing applied to the wrong picture.

3 Alternatively, right-click the History step and choose Create Snapshot, or press Ctrl/⌘+N.

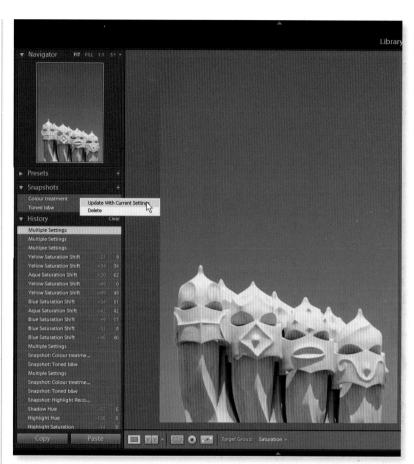

4 Create Snapshot adds a single record to the Snapshots panel (F7)—much easier to read than the History panel's lengthy list (it records every single editing step). Click a Snapshot to restore the picture to that state.

7 If you make editing changes and want to roll them back into the Snapshot, right-click it and select Update with Current Settings.

5 Rename a Snapshot by double-clicking it.

6 You can have as many items as you want in Snapshots.

In a multi-image editing environment, it's easy to make a mistake and apply the traditional Undo command to the wrong image. Instead, exploit the power of History and Snapshots.

Printing > Adding a copyright symbol to your pictures

Sad to say, but you can't trust everyone who might get their hands on your prints. It's easy enough in Lightroom to add text beneath the print, but sometimes it's better to use a copyright symbol or other way of defacing the pictures

themselves. It's not a cast-iron protection, but like adding such markings to web images, the goal is to make them less immediately useful and increase the time and effort the copyright thief would need to spend removing the symbol.

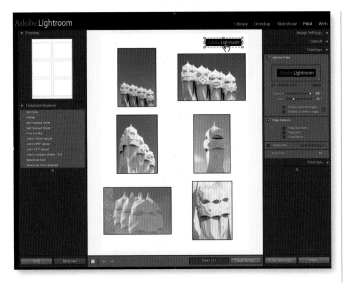

1 To add the copyright symbol, the first key step is to tick Identity Plate in Overlays. At first this shows the default Identity Plate for the current Lightroom database—if you want to use this as a page logo, drag it and position it where you want.

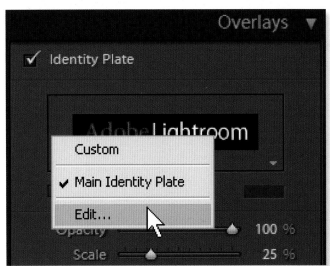

3 Click the Identity Plate preview in the Overlays panel and select Edit.

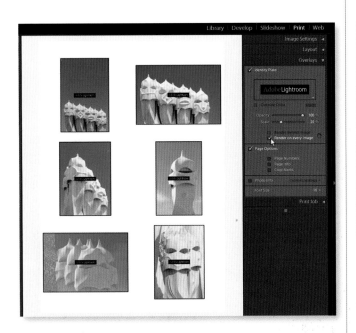

2 However, to mark each picture with a copyright, in the Overlays panel you need to tick Render on every image. Initially this setting stamps your default Identity Plate onto every picture.

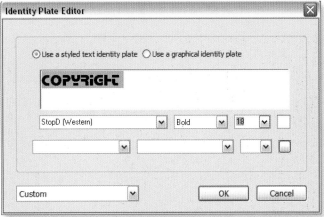

4 In the Identity Plate Editor dialog box, one alternative is to select "Use a styled text identity plate" and type in some text. Click OK, and the text will overlay each image.

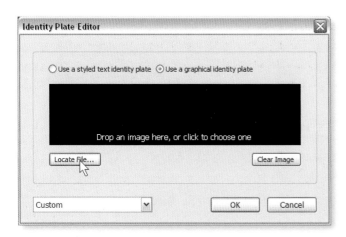

5 Alternatively, select "Use a graphical identity plate" and then point Lightroom to your Copyright file. Click OK, and the text will overlay each image.

6 Also in the Overlays panel, you can place copyright information below the print. Tick Photo Info.

7 In the Text Token Presets Editor, select the information that you want to add.

Always save a template when you've spent time customizing a layout. Also, if you're working with a multiple printers, try pressing the letter I on your keyboard—this displays a transparent overlay showing the current printer name.

Printing full page

Many printers offer a full-page option, and this is just one of
the tools you can use to maximize the print area when you
output your images.

1 Switch to the Print tool and you'll see your image in the center
of a print preview, probably with borders all around. Check that
these borders are the margins by switching on the Show Guides
options in the right panel.

2 Click *File > Print Setup* and set the printer to the borderless
mode appropriate for your paper.

3 Choose the
Maximize Size
preset. The preview
will now show bars
surrounding your print
unless its dimensions
match the paper size
perfectly.

4 Choose the Auto
Fill Frames option
in the Image Settings
and the image will be
expanded to fill the
paper, cropping equally
at either end.

5 Finally, if you'd like
to adjust the crop,
click and drag over the
print. The Hand tool will
appear, allowing you to
reposition the crop.

Tip > Copyright

If you want to type the copyright logo, press
Alt/⌥+G on a Mac or, if you're using a Windows
machine, either press Ctrl+Alt+C or hold
Alt and press, in sequence, 0, 1, 6, 9.

Creating a transparent copyright symbol in Photoshop

1 Create a new file in Photoshop, delete the Background layer, activate the Shapes tool, and select a copyright shape.

3 In the Layers palette, set the shape's Fill opacity to 0%.

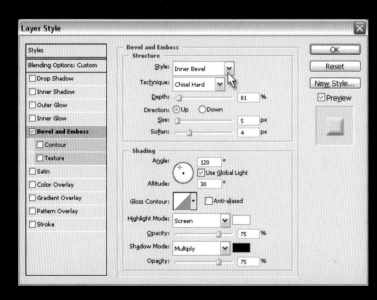

2 Right-click the shape's layer in the Layers palette and choose Blending Options. Go to Bevel and Emboss and add some bevel settings. Click OK.

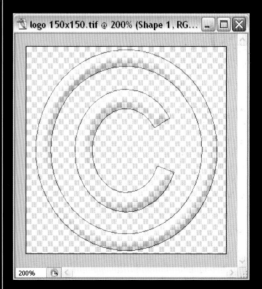

4 Save the file as a TIFF. Notice I've used the dimensions of my copyright symbol, 150 × 150 pixels, in the file name.

Advanced topics

Lightroom's image processing is mainly designed for a workflow where you need to large numbers of images. Tweak the white balance, adjust the exposure, fine tune the contrast and colour rendition, and sort out those dust spots. Lightroom is all about throughput and efficiency, not the one-off print. We're essentially talking about image correction, not creativity.

Yet Lightroom can be used for a surprising number of creative effects, and apply them to many images at a time. Beefing up blue skies is the most obviously useful, but you can make more far-reaching tonal changes and simulate cross processing, or burn in the corners–increasing rather than correcting vignetting.

So it's important to have an idea of just how much creative adjustment you can actually perform in Lightroom. You also need to know its limits, and when it's time for Photoshop and the pixel level manipulation that is still its speciality. That also means you'll need to integrate the work you do in Lightroom with Photoshop - and other specialist image editors–so that your workflow remains smooth and efficient.

The polarized image

The polarizer is perhaps the filter that has best survived the switch to digital capture. While a neutral gradient and color control filters can be simulated in Photoshop, the polarizing filter means a fundamentally different image reaches the sensor. The capture contains fewer reflections, less haze, foliage becomes rich and green, and clouds are clearly defined against strong blue skies.

Though metadata-driven editors like Lightroom are mainly designed for adjusting the overall image appearance, there are ways to use its tools to approximate the results of a polarizer. The obvious tools, the Vibrance and Saturation sliders, affect the entire range of color and that means they are often a blunt instrument. Lightroom's Color Adjustments panel is the expert's choice.

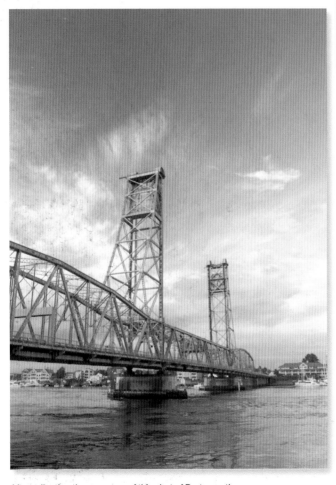

After adjusting the exposure of this shot of Portsmouth, New Hampshire, the sky was too weak.

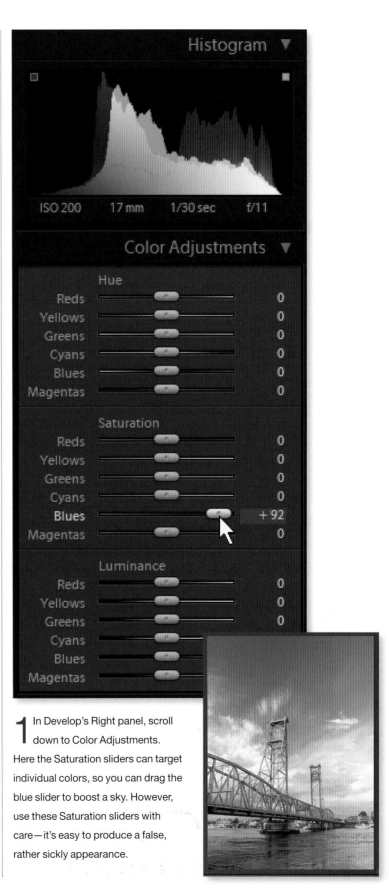

1 In Develop's Right panel, scroll down to Color Adjustments. Here the Saturation sliders can target individual colors, so you can drag the blue slider to boost a sky. However, use these Saturation sliders with care—it's easy to produce a false, rather sickly appearance.

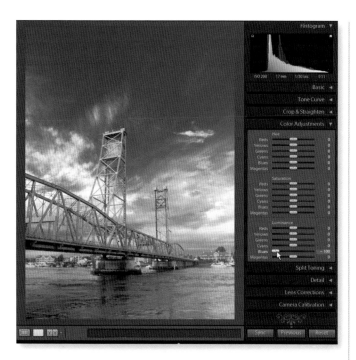

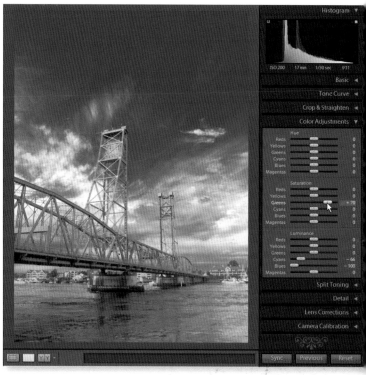

2 The Luminance sliders are a much better choice because they only vary the targeted color's brightness, not its color intensity. Dragging a Luminance slider to the left will darken the chosen color, so for a strong blue sky, drag the blue slider to the left. So here the blue sky is darker, and without a color shift, and the clouds stand out much more clearly.

3 You can also drag other Luminance sliders to the left. Here the sky is made even stronger by also dragging the cyan slider to the left, and also notice how increasing the green's saturation has emphasized the bridge's paintwork.

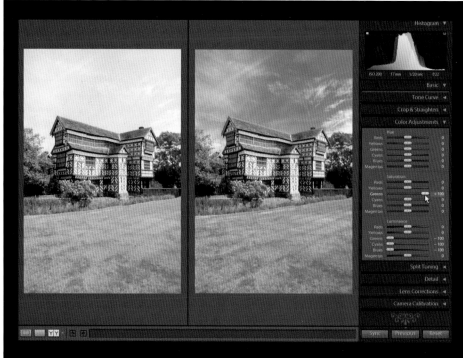

When you want to beef up more than one color, use the Saturation and Luminance sliders in combination. Here the sky was strengthened by Luminance's blue and cyan sliders, while the grass lawn benefited from my darkening the green and boosting its saturation.

Creative vignetting

Darkroom workers routinely darken or "burn in" areas around a picture's edge, typically skies and corners. It can help balance a print's appearance, direct the viewer's eye into the picture, and contain an image that would otherwise bleed out into white surroundings.

Lightroom's vignetting control is mainly designed to counteract image degradation and corner darkening that sometimes results from mismatched lenses and cameras. The combination of smaller frame sensors and full-frame lenses means many photographers never encounter this problem. Yet they may occasionally wish to lighten the corners for creative effect. Equally interesting, Lightroom's Vignetting slider is also suitable for burning in the corners of an image.

1 A conventional application of the Vignetting slider would be to drag the slider to the right and reduce any vignetting from a mismatched lens and camera.

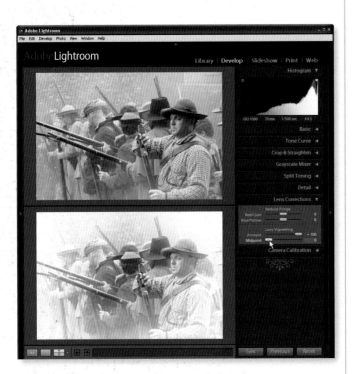

2 One creative use might be to lighten an image from the corners. Drag the Vignetting slider to the right, and its Midpoint partner to the left. This doesn't work with every image, but certainly suits this picture's gunpowder-filled atmosphere.

3 Another creative approach is to increase vignetting. Just drag the slider to the left. For this picture of an American Civil War reenactment, the vignetting and the toning work together to enhance the period feel.

4 You can also draw attention to a subject by increasing vignetting. Here the only difference between Before and After is that the Vignetting slider is dragged hard to the left.

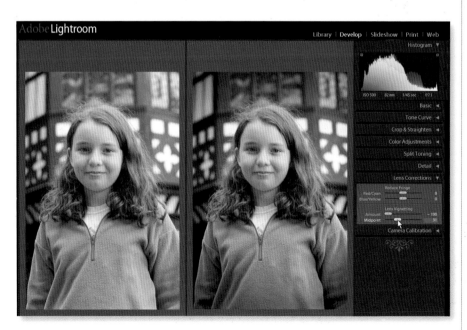

5 Drag the Midpoint slider left to increase the area affected by the Vignetting slider. These effects work equally from the corners, so they may not suit images where the main subject is off center. Dragging the Midpoint slider any more to the left would darken this girl's face too much.

6 Don't overdo the vignetting. Here I had already boosted the blues and green to give the picture a polarized look. In fact, vignetting is often most pronounced when using a polarizing filter.

Cross processing

Cross processing involves developing slide film with color negative chemicals, or vice versa. With practice, and trial and error too, eye-catching color and contrast shifts can be produced consistently and predictably. For a period in the 1980s, cross-processed images seemed to be in every magazine and were especially popular in fashion photography. While tastes have moved on, the look has remained popular and the original technique's destructive character has meant there has been no end of popular recipes to simulate the look in Photoshop.

Lightroom's main role is to correct and output large numbers of photographs, not the creative treatments for which Photoshop is rightly famed. But with cross processing we're only talking color and tonal shifts, so Lightroom can easily be used to create such effects.

1 In Develop's Basic panel (F8), adjust the image's tonality as normal, and perhaps introduce a bit of contrast with a gentle S curve in the Tone Curve panel.

3 Still in Split Toning, drag the Highlights' Hue slider to around 35, making the image's highlights a yellow tone.

2 Next, go to Split Toning, and drag both Saturation sliders up to 70-80%. Your photograph will go a gruesome red, but this step means you will be able to see the effect when you drag the panel's Hue sliders.

4 Drag the Shadows' Hue slider into the cyan-blue range. It'll vary according to your image, but a value of 175 is a good starting point.

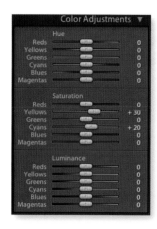

5 In the Color Adjustments panel, increase the Saturation of the yellows and blues a touch.

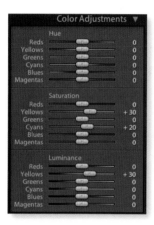

6 Also in the Color Adjustments panel, drag the Yellows Luminance slider a little to the right to lift their brightness. And that's about it—if you wish, go back and adjust the image's tonality to suit your taste.

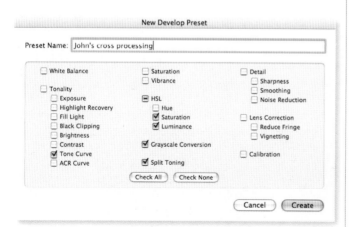

7 As usual, once you've worked out the steps it makes sense to save your effect as a Develop Preset. Click Add in Develop's Left Panel (F7) and then tick just the relevant boxes—Tone Curve, Saturation, and Luminance, and the Split Toning controls. Here I've selected Grayscale conversion, too—this will reset the picture to color if I apply my Preset to a picture which has previously been converted to black and white.

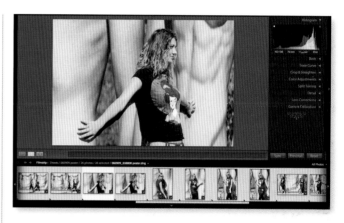

8 Apply your treatment to the rest of the sequence by revealing the Filmstrip (F6) and clicking Sync. You'll need to tick the same boxes as when creating a Preset.

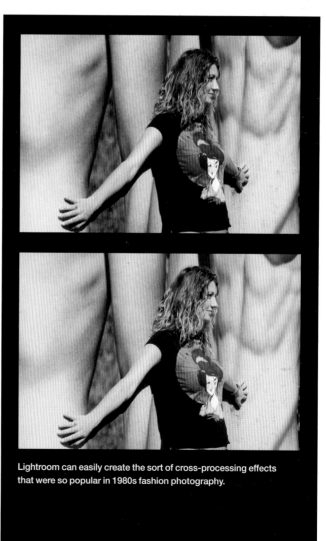

Lightroom can easily create the sort of cross-processing effects that were so popular in 1980s fashion photography.

Non-raw originals

Shooting raw or JPEG is often a matter of heated argument, and you'll still find many professionals and enthusiasts who proclaim that they get the shot right in camera and see no advantage in shooting anything other than JPEG. They may indeed be so skilled, or their deadlines may leave no time to batch convert from raw, the subject material may not merit more considered output, or they may simply carrying insufficient memory card capacity for an event. As well as decisions made when shooting your pictures, there can often be a need to produce versions of images you've already worked on

in Photoshop. These may be old work, saved as TIFF or PSD, or brand new pictures which were spoiled by, for example, converging verticals, severe dust spots, or other imperfections that are well beyond Lightroom's scope.

However you've ended up with mixed formats, it's good to know that Lightroom is agnostic in this battle of principles and treats JPEG, TIFF, and PSD files all as first-class citizens. It imports them just like raw files, creating previews and thumbnails, not changing the original file but holding your editing instructions in its database until it's time to create export copies of the files.

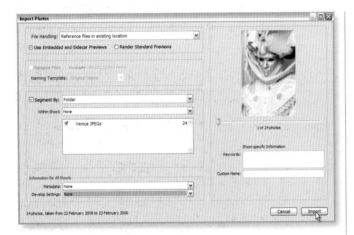

1 Import the files as normal. Here I've a group of files shot as JPEGs. Returning to them later, I felt the color was nowhere near as rich as it had seemed in the excitement of the moment.

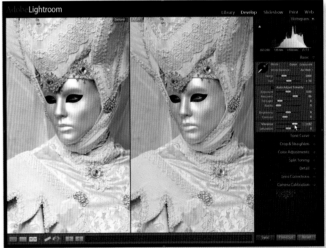

3 Use Quick Develop and the Develop module exactly as you would with raw files. Here I adjusted the exposure settings, but the big difference was made by dragging the Vibrance slider.

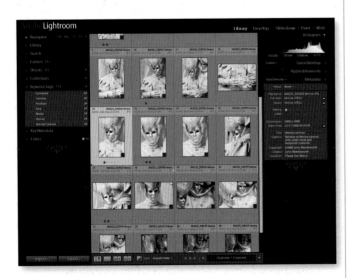

2 Once the files are in Lightroom's Library, treat them like any other image type, adding as much metadata as you need.

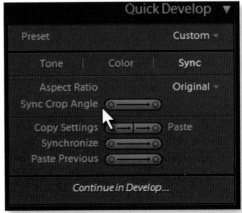

4 In Library, select all the images in thumbnail view (G) and click the Sync button in the Quick Develop panel.

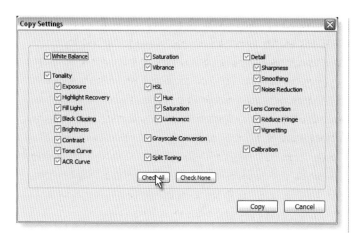

5 Choose the Develop adjustments that you want to copy to the other images.

Here the Sync operation is in process. Lightroom highlights the "most selected" image, the one which I'd taken into Develop, and is halfway through sending those adjustments to the rest of the shoot.

7 Often you will send the export files to a new folder, but Lightroom does let you choose the same folder as your originals. This means it's possible to overwrite your original JPEG, TIFF, and PSD files, in a way you can't do with raw files. If you really want to do this, click Continue.

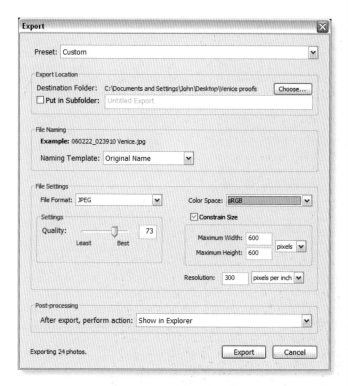

6 Just like when you are working with raw files, Lightroom does not change the originals and no output exists until you tell it to export the files. Use *File > Export* and complete the dialog box as required. Here I wanted to output smaller versions of my pictures.

8 If you choose Continue (Don't Overwrite), then Lightroom changes the names of the output files. Here you can see the exported versions have a "-2" suffix.

Photoshop workflow > Blended exposures

Some scenes contain highlights and shadows that are so far apart that digital cameras cannot yet capture the whole range of brightness. Either the highlights or shadows are devoid of visible detail. One approach is to decide where detail is most important and to expose accordingly. Often this means underexposing so the viewer sees detail in the highlights, and the dark shadows are left to look after themselves. Another approach is to shoot a pair of images, bracketed a few stops apart, and blend them later on the computer. It can be a very effective technique, especially for slower-paced work like landscape photography.

In the future, programs like Lightroom may be able to cope with simple multiple exposure blending tasks. But in any case, pixel-level editing is what Photoshop is for, so you'll often need to switch to it for correction of converging verticals, cloning, and dealing with severe dust spots. It's a long list and so it's essential to learn to loop out of Lightroom and into Photoshop, and then back to Lightroom.

1 First do any Lightroom adjustment work in Quick Develop or Develop. Then in Library's thumbnail grid, select the image or images you want to edit in Photoshop. This scene contained a huge contrast range, so I shot the frames two stops apart, knowing I could create a composite image later.

2 If you are editing a raw file, the Edit Photo dialog gives you only one choice and Lightroom will open the images directly in Photoshop, bypassing Adobe Camera Raw.

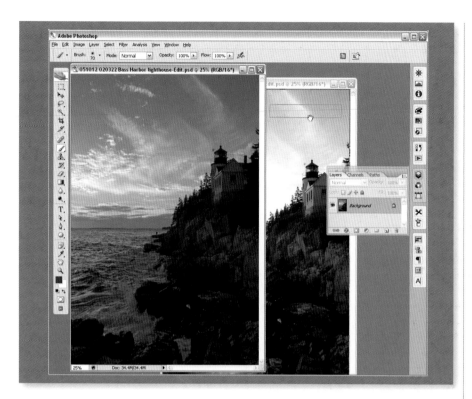

3 Lightroom opens the two pictures in Photoshop. If you need to perform a task such as blending, drag one image from the Layers palette, hold down Shift and drop it in the other image's window.

5 When your Photoshop work is done, activate the Lightroom application again and you'll see that it created PSD files in the same folder as the originals. In this case, the lighter of the two frames was unnecessary, so it could be deleted by right-clicking the thumbnail and selecting Remove and Move to Recycle Bin/Trash.

4 Do your Photoshop work. Here I began by adding a layer mask and drawing a gradient. The composite image consisted of the sky from the underexposed shot and the lighter shot's water and coastline. The finished Layers palette shows all the other local contrast and saturation adjustments I made on this picture.

Lightroom's Edit in Photoshop command creates a new Photoshop file in the same folder as your original, with the filename suffixed with "Edit," and automatically adds the new picture to the Library.

Other image editors

While Photoshop has ruled the digital-imaging roost for many years, it has always left space for third-party plug-ins and standalone applications for sharpening, noise reduction, lens correction, and other specialized tasks. The same will be true of Lightroom. Its architecture allows for the inclusion in the main Lightroom interface program of third-party developed modules, which I'm sure will soon start to appear. For now, after processing a picture in Lightroom, you can send it to another standalone program for further work.

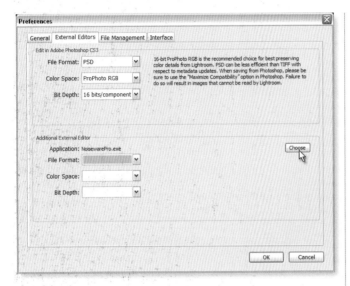

1 First, set up an external editor in Lightroom. Select *Edit > Preferences* on the PC or *Lightroom > Preferences* on the Mac and go to the External Editors tab. Click the choose button and point to the program—in this case it's the digital noise program Noiseware.

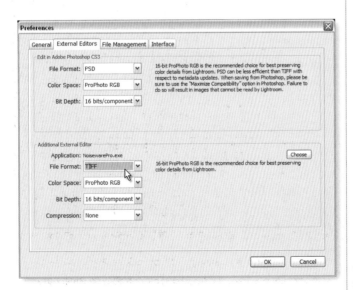

2 Set the export options to match the external editor's capabilities. When Lightroom sends an image to an external editor, it creates a TIFF or PSD file which the other program will receive, so it wouldn't make sense to send a 16-bit image to a program only able to handle 8-bit.

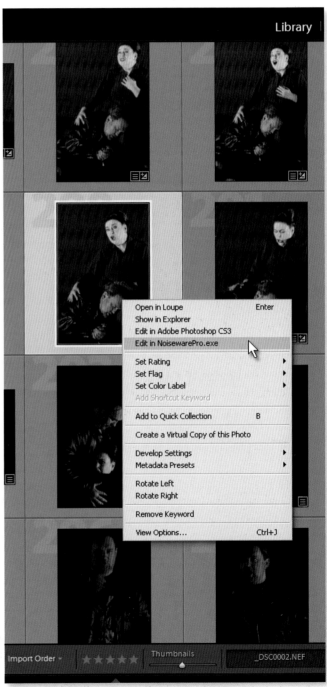

3 In Library, you can right-click a thumbnail in grid view (G) and select the option to Edit in your external program.

4 Alternatively, right-click the image when you're in the Develop module. For this shot, taken at ISO 1000, I had increased the noise reduction sliders in Develop's Detail panel, but the noise was still very pronounced and I like Noiseware for such extreme cases.

5 If you are processing a raw file or DNG, the Edit dialog informs you that it will save a TIFF or PSD and send that to the other application (in this case Noiseware).

6 If Lightroom is processing a TIFF or PSD file, it lets you decide whether you want to edit the original or a copy. In either case, Lightroom adjustments are not passed to the original or copy. If you want them to be applied before you print the image, you can always import the file after the other program's processing work, and then use Develop's Sync button to copy adjustments to the new file.

Drag and drop

When you tell Lightroom you want to edit a picture in Photoshop or with a secondary external editor, it creates a new **PSD** or **TIFF** file in the original's folder and adds it to the Library. This has the disadvantage that you may not want derivate files mixed in the same folders as your originals, but you can always move them later using Library's Folders panel. On the positive side, Lightroom controls the **PSD** or **TIFF** file from its birth, making it easy

to find and making sure it contains your copyright details and other metadata.

Alternatively, you can drag a file from Lightroom and drop it into the other application or its icon. If you do this, no **PSD** or **TIFF** file is created until you save one in the other program. This may be what you want, or not, but in any case you will have to manually import these files into Lightroom.

1 If you want to edit raw files **and** the other program can read XMP data (as Photoshop can), then export the XMP data. Select the items in Lightroom's Library and choose *Metadata > XMP > Export XMP Metadata to File*. This creates small XMP sidecar files in the same folder as the originals and means that other program reads your metadata and saves it to the eventual output file.

2 Another possibility is when you drag and drop files to which Lightroom is able to write metadata directly inside the original. Generally this applies only to publicly documented file formats such as DNG, JPEG, or TIFF. In this case, the other program may be able to read that metadata and save you work when you import its output to the Library. So select the items in Lightroom's Library and use *Metadata > Sync Metadata* to able to send the metadata directly into the file.

3 With the items selected in Library, drag them to the other program's icon or into its application window. It wouldn't be uncommon to be faced with a problem like mine here—dragging from Lightroom a Nikon raw file, an undocumented file format into which Lightroom does not embed metadata, and dropping it in Nikon Capture, a program which cannot yet read XMP sidecar files.

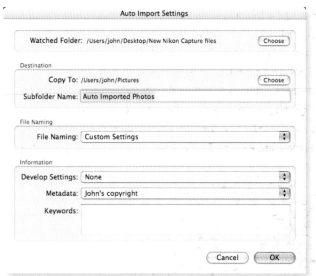

4 Complete your work in the other program and save the output file where you want on your file system. Here I saved my black-and-white Nikon Capture output into a folder on my Mac's Desktop.

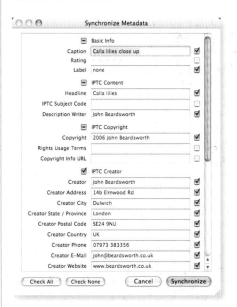

6 A smarter way is to let Lightroom import the images automatically. Under *File > Auto Import > Auto Import Settings*, point Lightroom to a folder such as my "New Nikon Capture Files." And make sure you tick Enable Auto Import. Then, in the other program, always save new derivatives in that folder. As a tip, I like to send such new files into a folder such as Auto Imported Photos—for me it's a holding area and makes it easy to add metadata, and then move them on to their ultimate folder location.

5 Unlike when you edit with Photoshop or another program, when Lightroom immediately creates a file and adds it to the Library, the drag and drop method produces no derivative file until you save it in the other application. Lightroom knows nothing about what this other program does, so you need to add it to your Library using *File > Import*.

7 If you have edited in another program, review the derivative file's metadata. If it has been stripped, select an original and then select the derivatives. Click the Sync Metadata button and copy the metadata across.

Moving work between computers

From times when it seemed unimaginable to own a computer oneself, we're now in a world where many photographers, professional and amateur alike, are armed with a small array of desktops and laptops. For managing and processing pictures, this creates particular problems.

Transferring pictures between computers is now a routine task, and it demands rather too much time and self-discipline. Too easily, pictures go missing, or are in multiple locations. As well as moving pictures, you need to take Lightroom's processing instructions and metadata from one computer to the other, and that's not as simple a job as copying your Lightroom's database files across. What if the pictures are in different folder paths on the two computers, or if you have a Mac and a PC? Lightroom's Binder feature is designed exactly for this purpose. It's not the only way to move your work, but is certainly the easiest.

What is a binder?

A Photo Binder is simply a folder into which Lightroom puts the photos, together with processing instructions and descriptive metadata.

1 In Library's grid view (G), select the photographs you want to transfer to another computer. This might be all the pictures in the library, or it might be a selection. Here I'd initially intended to transfer all the pictures of this pension protest in Rome's Piazza Navona, but then deselected a few images.

2 When you're transferring information between systems, it's good to audit the process afterward, so consider saving them as a Collection. Here I hit the B key and stored them as a Quick Collection.

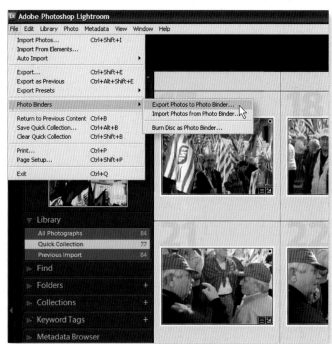

3 With the pictures selected, one way to create a Binder is via the menu: *File > Photo Binders > Export Photos to Photo Binder*.

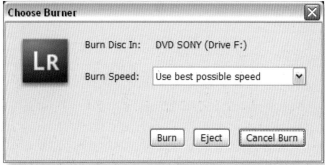

4 The *File > Photo Binders* menu has the option Burn Disc Photo Binder. Choose this option, put a writable CD or DVD into your computer's CD/DVD writer, and Lightroom burns the Binder directly onto the disc.

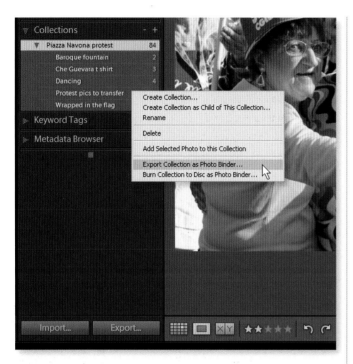

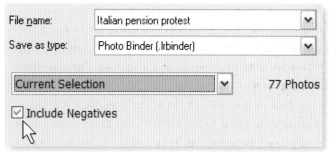

7 Normally you would leave Include Negatives ticked. You might untick it if you move the files without using Lightroom, or if you want to take a backup of the processing and descriptive metadata.

5 You can also create Photo Binders directly from Library's Folders, Collections, or Keywords panels. You don't need to select the picture—just right-click the items in the panel.

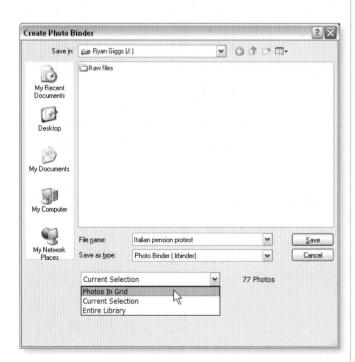

6 However you start the creation of the Photo Binder, Lightroom will ask you to name it. Here I entered "Italian pension protest." The choice of Photos in Grid, Current Selection, Entire Library only appears if you used the menu *File > Photo Binders > Export Photos to Photo Binder*.

8 Lightroom creates a folder or disc which can then be transferred to the other computer. So here I would copy the folder "Italian pension protest.lrbinder" over the network to my Mac, or insert the CD/DVD that Lightroom has created.

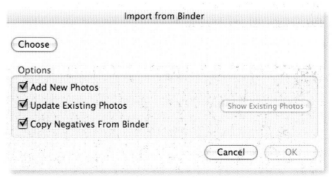

9 Bring pictures into your other computer's Lightroom by selecting *File > Photo Binders > Import Photos to Photo Binder*.

10 You will need to point Lightroom to the disc or folder containing the Photo Binder. If you're importing from a disc, point to the disc itself. If you transferred the "lrbinder" folder, just point to that top-level folder, not to the folders that it contains.

Here the Mac has almost completed importing the Photo Binder that I created on my PC.

11 The other key is to specify where you want the files to be stored.

Sharing and backing up your presets

As well as needing to move pictures and the work you've done on them in Lightroom, there are parts of a working Lightroom environment that you may want to copy from one computer to another. After only a short period of working with Lightroom, you will accumulate all sorts of presets and templates on your main computer. It would make little sense if you had to recreate your copyright template each time you replaced your computer, or had a slideshow template that was different on your laptop from the one on the desktop machine on which you rehearsed the show. Even while Lightroom was in its public beta, enthusiasts were already sharing Develop presets—something that would also work well in multiuser environments such as small studios. So it's important to know how to migrate and synchronize those important features—and include them in your backup plans.

If you save a preset on one of your computers, there's a fair chance you'll want it on your other machines.

1 In most parts of Lightroom, you can go directly to the templates folders by right-clicking an item in the Presets and selecting Show in Explorer/Finder from the context menu. This opens an Explore/Finder window and goes straight to Lightroom's templates area and to the folder for that type of Preset.

2 Presets and templates are stored in the user's application folder, which varies depending on your operating system. On both PC and Mac the same folder names are used, and they are named logically. So templates from Web are stored in Web Templates, from Slideshow in Slideshow Templates. Using Explorer/Finder, you can copy a template from a folder on one machine and paste it into the correct folder on another. On a Windows PC, presets and templates are in: **C:\Documents and Settings\USERNAME\Application Data\Adobe\ Lightroom**. On a Mac, look in (**User**)/**Library/Adobe Lightroom**.

3 You'll need to restart Lightroom to make the template or preset visible. Generally it shouldn't usually matter if you transfer templates between PCs and Macs, but check Metadata Templates carefully when you have moved them from one platform to the other, especially if they contain non-English characters. Print Templates may not operate as expected on the other platform.

4 Include these folders in your routine system backups. Though they are just text files, it'll save you time recreating them.

Keywords

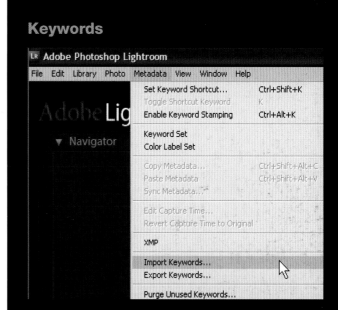

When you've spent a lot of time building up a long list of Keywords, and perhaps added a hierarchical structure, it would be irritating to have to recreate that list on another computer. Additionally, many photographers use controlled and specialized vocabularies which might be supplied by stock agencies and other third parties, so it's not surprising that Lightroom has menu commands for exporting and importing keyword lists. It's as simple as *Metadata > Export Keywords* and *Metadata > Import Keywords*.

Hacking templates

Individual template files have file names with ".agtemplate" extensions but are just simple text files which you can edit in text editors like Notepad or TextEdit, if you're so inclined. Make sure you back up the file first.

Glossary

Actions

Photoshop term for recording keystrokes and editing steps in a format that can easily be repeated.

Bitmap

A data file with a rectangular grid of pixels in which each pixel's color is individually defined. (Strictly speaking, a bitmap has only black or white pixels, but the term has come to apply to all pixel-based images.)

Bitmap editor

A digital image editor like Photoshop in which the image is stored as a grid of pixels and the editor directly changes the pixel values.

Browser

A program that examines folders in real time, displays image files' thumbnails and large previews, and allows metadata entry. Searches are performed by examining the file system. Examples include Bridge, Photomechanic, Breezebrowser. (As opposed to web browser.)

Catalog

A program that records the contents of folders, displays image files' thumbnails and large previews, and allows metadata entry. While folders may be shown, their contents are not updated in real time but only when instructed, and searches are performed upon the database. Examples include Extensis Portfolio, iView Media Pro, iMatch, ACDSee.

Channels

The three colors whose brightness values are used to record the color of a pixel.

Clipping

An absence of detail in image areas because the brightness values record either complete black or pure white.

Controlled vocabulary

A list of words and phrases, often supplied by stock agencies or other image buyers, to standardize the descriptions of images.

Derivative

An image file produced from an original, for instance the JPEG or PSD file saved after a raw or DNG original has been edited in Photoshop.

Descriptive metadata

Metadata that describes the image and including captions, keywords, and locations but excluding details of image processing or related instructions.

Digital asset management

The practice of downloading, backing up, evaluating, describing, categorizing, selecting, and archiving digital image files.

DNG

Digital Negative, an openly documented digital photograph format sponsored by Adobe and containing the raw image data and XMP metadata. Considered as an original.

Embedded metadata

Metadata that has been written directly into the image file.

EXIF

Digital image metadata written by the camera and including exposure, lens, and camera details.

Extensible

A method of recording data which allows users to add their own information categories to the agreed structure.

Instruction sets

In the processing of metadata, the record of steps taken to edit an image.

IPTC

One of the earliest widely used formats for recording digital images' metadata and using a list of metadata fields defined by the International Press Telecommunications Council. Now superseded by IPTC-Core.

IPTC-Core

An extensible XMP-based format for recording digital images' metadata.

JPEG

An image file format used for both originals and derivatives. JPEG's popularity stems from its use of a "lossy" compression system that abandons some image data in exchange for smaller file sizes.

Keywords

Words or phrases used to describe images, usually referring specifically to the IPTC keywords field.

Lossless

Conversion of image data from one format to another without losing any data accuracy.

Metadata

Information about an image, describing its content in words, its copyright, and its ownership.

Metadata-driven editor

An image editor that processes digital images by recording in its database the instructions to adjust the color, brightness and other characteristics, and only performing those editing steps on the actual image when instructed to render a derivative file or output a print. Examples include Apple Aperture and Lightroom.

Offline storage

Images stored on CD, DVD or on hard drive not connected to the computer.

Preset

In Lightroom, a stored set of editing instructions, metadata, slideshow, web gallery, or print layouts.

Processing metadata

Metadata that records instructions of how to process the digital image, often included in XMP sidecar files or in certain file types' XMP headers.

PSD

Photoshop's default file extension, able to hold 8- or 16-bit data.

Ratings

The subjective quality of an image, usually on a 1-5 scale, applied in a browser or cataloging software. Usually more permanent than the use of labels.

Raw converter

Program that decodes or demosaics a raw image file and converts it into a bitmap image. Examples include Adobe Camera Raw, Bibble, CaptureOne, Rawshooter.

Raw file

The image data recorded by a digital camera's sensor in the camera maker's proprietary file format and containing the unchanged image data, one or more embedded JPEG thumbnails and a preview.

Sidecar

A small text file, usually in XMP or XML format, that resides in the same folder as a raw file and carries its descriptive and sometimes processing metadata, so avoiding writing that data to directly the raw file.

TIFF

A common file format for images, able to hold 8- or 16-bit data.

Template

In Lightroom, a stored set of editing instructions, metadata, slideshow, web gallery, or print layouts.

Virtual sets

A way, like Lightroom's Collections, of organising and subdividing images in cataloging software to gather them into hierarchical groups similar to a folder tree.

XML

Extensible Markup Language, a standardized text file format where the data is marked with tags to identify.

XMP

Extensible Metadata Platform, an XML-based style of writing metadata to images and/or sidecar files.

Index

Essential keyboard shortcuts

The key to working at speed with Lightroom is to know a few essential keyboard shortcuts. But what's absolutely critical to one user is something that another person might never require. Luckily, Lightroom's menus show the keyboard shortcuts so you can memorize those you need most, but here's my suggestion for those most worth learning. I'd also recommend running through them one after another—it's a great way to discover new features, as well as speed up your work.

Hide or display the major panels	
F5	Top panel
F6	Filmstrip
F7	Left panel
F8	Right panel
Tab	Left and Right panels
Shift+Tab	All panels
F	Full screen modes (cycle)
L	Lights out modes (cycle)
T	Toggle the Toolbar

Getting pictures in and out	
Ctrl/⌘+Shift+I	Import image
Ctrl/⌘+Shift+E	Export image
Backspace	Delete image

Library > Evaluating pictures	
0-5	Star ratings
6-9	Set colors
P	Pick Flag
U	Remove Flag
X	Reject Flag
I	Information overlay (cycle)
J	View thumbnail details (cycle)
Ctrl/⌘+[or]	Rotate

Library > Organizing and finding	
Ctrl/⌘+F	Go to Find panel
Ctrl/⌘+L	Switch filters on or off
Ctrl/⌘+A	Select all images
Ctrl/⌘+D	Deselect all

Collections	
Ctrl/⌘+N	Make a new collection
B	Add selected pictures to Quick Collection
Ctrl/⌘+B	Display the Quick Collection
Ctrl/⌘+Shift+B	Empty the Quick Collection

Working with stacks	
Ctrl/⌘+G	Stack selected pictures
Ctrl/⌘+Shift+G	Break up the stack
S	Open or close the stack

Library > Copying and pasting Develop setting	
Ctrl/⌘+C	Copy all
Ctrl/⌘+Shift+C	Open the Copy Settings dialog box
Ctrl/⌘+Shift+V	Paste the Develop settings
Alt/⌥+Ctrl/⌘+V	Paste previous Develop settings

Develop	
J	Toggle clipping
W	White balance
R	Crop
A	Constrain crop aspect ratio
N	Spot removal
Ctrl/⌘+N	New snapshot

Moving around Lightroom	
G	Go to Library Grid view
D	Go to Develop
W	From Library, go to Develop and set White Balance tool
Z	Zoom in or out
`	Toggle zoom view

Acknowledgments

This book is dedicated to my mother, who continues to inspire me, and to my family, particularly Dad, Ann and Allan Williams, Allan and Jane, Tom, Alice and Sophie. Particular thanks should go to my friend Clive Barda who very kindly arranged for me to photograph the ENO in rehearsal, and who has been very generous with the wine. Thanks to Ryan Giggs, too.

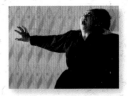